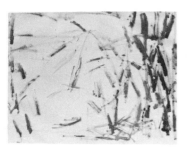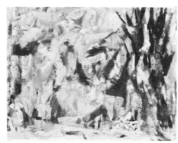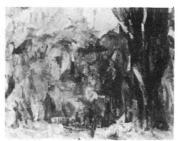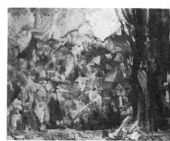

CREATIVE PAINTING

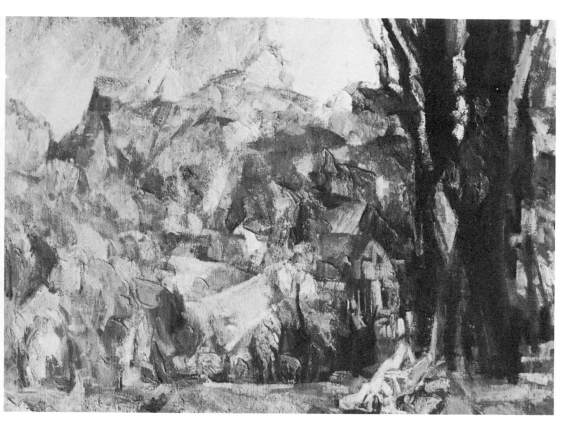

AND DRAWING

BY ANTHONY TONEY

Illustrated with Reproductions of the Artist's Work

With an Introduction by RUDOLF ARNHEIM

DOVER PUBLICATIONS, INC., NEW YORK

Published in Canada by General Publishing Company, Ltd., 30 Lesmill Road, Don Mills, Toronto, Ontario.
Published in the United Kingdom by Constable and Company, Ltd., 10 Orange Street, London, W.C.2.

Creative Painting and Drawing is a new work published for the first time by Dover Publications, Inc., in 1966.

Library of Congress Catalog Card Number: 66-14557

Manufactured in the United States of America
Dover Publications, Inc.
180 Varick Street
New York, N.Y. 10014

To Anita and Adele

I wish to acknowledge the important assistance of Herzl Emanuel, the stimulating interest and encouragement of Mr. and Mrs. Hayward Cirker, and the cooperation of Beverly Walters, Jane Peck, Jackie Friedman, and my wife Edna. I am also grateful to the owners who have allowed paintings to be reproduced in this book.

INTRODUCTION

Artists, though men of images, frequently are willing to speak about their art. To be sure, they rarely care to interpret specific works verbally because in talking about the meaning of a painting they rightly fear they might replace the pictorial statement with a set of concepts necessarily cruder than those visible on the canvas. Verbal concepts are no less subtle than visual ones but they are least subtle when called upon to describe the sensory appearance of things. The refinement of visual concepts that creates a particular gesture, a particular encounter of lines, can be rendered verbally only by clumsy or un-fitting generalities.

The artist speaks readily, however, about technique and also, at times, about the principles that underlie his activity. In this, his urge is not different from that of any man who tries to formulate the order by which he lives. Such an account is generally not given for the sake of teaching alone, although the painter Anthony Toney is very much of a teacher. It is the response to a need to codify what is half sensed and half known and to preserve the fruits of experience more reliably. To fulfill such a need seems to me more natural for an artist than to fear that the spirit of inspiration might be dispersed by intellectual rules. The great art of all times has been produced in obedience to specifically defined norms. When such norms become overbearing they do so generally as a reaction to a weakened sensibility, which would profit little from being left alone.

Traditionally the rules of the trade were intended to tell the artist what was prescribed and what was forbidden. This is no longer so. We now think of rules as "if-so" propositions. They do not tell us what we have to do but

rather predict what will happen as a result of a certain procedure. They also say: If you wish to obtain a particular effect this is what you can do! The approaches from which the artist may choose are many. Never before in the history of man has he been offered the terrifying freedom to pick any one among the innumerable styles, ancient or recent, that we have come to know and to appreciate. To identify some of these styles, to describe what their means are, what they achieve, and—perhaps—what human attitude and what view of the world they convey, this is now a principal purpose of any treatise intended to clear the minds of author, fellow artist, and student.

Yet the new freedom of choice must not be described as the sympton of a modern mind lost in a hopeless search for identity. Looking more closely, we begin to discern behind the disguises an underlying self. The outlines of Picasso's "classical" figures are not those of the *Nazarener* or of Ingres or Flaxman; nor are they those of the Greek vase painters. His shapes look neither like those of children's paintings nor those of African sculpture. Such sources are drawn upon but their gifts are transformed into something that begins to reveal itself to us as a distinct individuality. Perhaps in our time individuality lies less overtly at the surface of colors and forms. Perhaps it can manifest itself in more varied ways, yet be equally special at its core. This may be true for many a modern artist. It may be true for Anthony Toney, whose work ranges from lifelike portraiture to symbolic ghosts and abstract movement.

The variety of Mr. Toney's experience and tastes enables him to go along with many students, unimpeded by prejudice. But in his presentation there is no lack of preference. The most basic is perhaps the insistence on contrast as the primary motif. "The main theme," he says, "becomes the main contradiction." He speaks of colors as "acting as competitive forces," and the point of view of "realism," which has his obvious sympathy, is said to stress "dynamic contradictions, the conflict of opposites that transform each other into and out of each other." No doubt this preference is characteristic of much modern art—as distinguished from such basic structural conceptions as harmony or hierarchy in other style periods. No doubt also that it is related to a view of modern life as pervaded by social and philosophical contradictions, a view expressed at the very outset of Mr. Toney's essay.

At the same time there is evidence of the healthy and necessary unawareness of the artist's own style. Style results from the coincidence of world view and invented form. This coincidence determines any true artist's belief that in the last analysis his own way of representing the world is the only adequate one. To be without this belief means to be unable to create in good faith. The four approaches Toney describes—those of classicism, romanticism, naturalism, and realism—have two different meanings. On the one hand, they are deliberate abstractions, simplified types of artistic procedure. On the other hand, they are historical categories and as such he makes three of them bear the stigma of onesidedness, which is overcome by the synthesis embodied in the fourth. This is what I mean by the healthy illusion, the artist's version of absolute truth.

When the artist speaks about art, to his students, in his conversations and letters, or in his books, he becomes a theorist; hence there should be final agreement of what he says with what the philosophers and psychologists say on the same subject. A difference of emphasis may induce the philosopher to deal with art mainly as one branch of human cognition or make the psychologist concentrate on the motives of the artist as a person. But when they explore the same subject their results should tally. There are happy examples of such mutual confirmation, and some of them can be found in the present book. Even so, the theoretical statements of artists tend to have a flavor of their own. The full-time theorist endeavors to use strictly defined concepts systematically and to back his assertions with proof. It is the artist's function to offer notions of more personal, more spontaneous, and therefore somewhat accidental connotation, based on what looks self-evident to him at a given time. When we read the artist, it is often as though we watched tamed wildlife, to be admired for the approximate orderliness of its paces; while the performance of the professional theorist may recall the pantomime of robots, tolerably lifelike on occasion. At the beginning of his treatise on painting, Leon Battista Alberti says: "Having to write about painting in these scanty comments, to make what I say quite clear I shall primarily take from the mathematicians those things which will seem to me appropriate. Once they will be understood I shall declare (as far as my wit permits) from these principles of nature what painting is. But in all of my argument I wish it to be observed that I shall speak of these things not as a mathematician but as a painter. For mathematicians consider the species and forms of things by reason only, separate from any matter. But since I wish that the thing be placed in front of our eyes I shall employ for my writing, as the saying goes, a more robust goddess of wisdom [*una più grassa Minerva*]." Caught napping among his necessarily simple notions by this more robust Minerva, the theorist finds himself confronted with some of the complexity of actual artistic experience. Students and artists, on the other hand, will receive advice more readily when it comes with the immediate reference to studio problems and thus bears the stamp of authenticity.

The artist, in speaking of his trade, has one further privilege: he can take its value for granted. He need not bother to ask why he paints nor to what end he does so. This does not mean that such questions are foreign to his mind. On the contrary, they lurk powerfully in the conscience of the more thoughtful artist. Anthony Toney, well aware of them, speaks implicitly of the obligations of the painter. By showing that the shapes on the canvas can express a content and must fit a meaning he exhorts his readers to accept the artist's profound responsibility.

As to what more precisely the nature of this responsibility might be, the artist, as any modern man, is largely on his own. When, early in the fifteenth century, Cennino Cennini presented his contemporaries with his book on painting, he stated that he had made and composed it in reverence of God, the Virgin Mary, St. Eustace, St. Francis, John the Baptist, St. Anthony of Padua.

and all the man and woman saints of God, as well as in reverence of Giotto, Taddeo, and his teacher Agnolo Gaddi. Mr. Toney cannot rely on such authorities. He must depend essentially on his own inner voice. Fortunately it is a voice worth listening to.

March, 1966 RUDOLF ARNHEIM

CONTENTS

PAINTINGS BY ANTHONY TONEY

COLOR PLATES

PREFACE

The world of art, like the larger environment that surrounds and produces it, exists today in a state of confusion. Ours is a world of sensation and physical impact, of sated sensibility and exposed pretensions. Never more than in this time of great plenty has life been at once so full of promise and so terror-ridden.

Part of the promise of the times has been a mushrooming of art activity. There has been a rebirth of the "village" tradition, a multiplication of artists, artisans, students, art centers and galleries. Unfortunately, examined closely, this world will be seen to share all the commercialism, faddism, and fanaticism of contemporary society.

It is no small task to make sense of such contradictions in a small book on drawing and painting. My work in adult education, however, has indicated a need for such a book, one that will clarify primary movements in art while incorporating information that will be useful to the art student. This book is such an attempt: to suggest the essence of the principal directions in art, their various explanations of the creative process, and the influence of those ideas upon actual current and past practice. The author's bias toward creative realism provides the main thread of the counterpoint of thought and practice.

Inevitably a work of such brevity will seem dogmatic to some and perhaps unrelated to other pertinent works. Such separation from sources was deemed necessary if the work was to remain simple and direct.

The book is divided into three main sections. Part I attempts to establish a brief framework of artistic ideas. Part II elaborates these in a variety of

1

practical problems and approaches. The final section, Part III, summarizes the essential qualities of the visual language of drawing and painting, their vocabulary and structural relationships.

Words, unfortunately, are not that language; anyone who has written on art knows of the inevitable gap between words and sensuous visual perception. Illustrations from the artist's own work are included to help close that gap. The important thing is to base your reaction not on the words but on painting itself.

Read this book critically. Read thinking of the marks and paint contrasts on flat surfaces that will combine to form drawings and paintings, particularly your own.

PART I
THE PROBLEM

CHAPTER I
WAYS OF SEEING

To most of us reality is self-evident and there are no two ways of considering it. Reality for us consists of material objects that we touch and feel as well as our ideas about those objects and ourselves; any other view seems somewhat fantastic.

Yet most of us have absorbed all kinds of contradictions, many of them oppositions we are hardly aware of. With little apparent difficulty we entertain mutually antagonistic views about society, about art and life in general.

It is the thesis of this book that we should conceive of these contradictions as forces that act upon one another, influencing all that we do. This interaction is specific, momentarily resolved as a particular tendency wins, an inner conflict which may become intense, turbulent, or for periods remain calm. This conflict determines our prevailing values and goals, the character of our creative expression.

Such a conflict can be seen in the interplay of idea and actuality. On the one hand is the actuality of our world, on the other our ideas about that actuality. Our ideas stem from our experience, our sensations within that actuality, as well as from the sharing of ideas with others and the inheritance of ideas from the past. These ideas change and influence us and our activity even as the latter changes our ideas.

Most of us, further, have been confronted with the contradiction of mutually destructive evaluations of events and works of art. In this situation, victories for some become defeats for others; partisanship exists on all sides. It is important to find some means of relating these oppositions if we wish to make sense of our own direction.

We can, of course, feel that there should be no such sense. Each of us will accordingly act as we must and will gravitate to those who seem to share our direction and tolerate or oppose those who do not. We want, after all, a "right way." Yet what we find is that each way, each tradition, has its own heroes and that those of the past, however different they may be, are now equally accepted. We honor, side by side, Ingres and Delacroix, Michelangelo and Raphael.

Is there, then, some common necessity within good painting which makes it good? Must we rely upon sales promotion and the artists' prestige for our evaluations of art? Many painters are rightly discouraged by the commercial aspects of the present-day art scene.

Though human wreckage does include both art and artists, much nevertheless endures to give substance to our culture. Perhaps the reason seemingly contradictory "greats" can coexist is that reality itself is as rich in contradictions as the artist himself, and the artist's intention and practice do not always match. Even failure, as every experienced painter knows, can mean eventual success, and success failure.

In this regard, it is sometimes provocatively productive to tell a student that if he likes what he is doing it is probably bad, and if he does not, it is probably good. Despite this qualification, the student still needs to base himself upon his own sensibility even if it is often clouded by stereotyped goals and limited experience.

The same is true of the sophisticated painter. There cannot be any one style, good for everyone and for all time. Creativity is in enough bondage without these additional chains.

Progress in Art

Artists have fought their way out of many prisons even as they persist in creating new ones. The old is constantly being buried by the new. But is there actual progress in art? Certainly there is change; fetters are broken, discoveries are made, forgotten and found again. But considering art as art, is there progress?

If one thinks in terms of the sum total of human consciousness, the expansion of knowledge and growing complexity of life, and calls that progress, then art has surely contributed to it. But that does not mean that this work or that is necessarily better than others because it is of a more recent time. Even the best of the most recent work is not necessarily better than what came before.

"Progress" or "reaction" in art are terms related to specific struggles within particular periods as one art movement challenges another. Every artist considers himself avant-garde and is partisan in these combats, either as part of a group or alone. With his work he implicitly criticizes all others. The resulting "progress," however, should never be dissociated from the struggle that produced it.

Integrity

Works of art, on the other hand, are not all equal. Some possess greater insight than others on one or more levels. As art these works share the common aspect of containing an organic synthesis of discoveries significant to humanity. This wholeness gives them relative immortality. Thus a painting painted centuries ago functions for us today, though not necessarily in the same way as it did then, or on the same levels. Its relationships remain, awaiting our response.

The work of art possesses its own integrity, its roots, and its promise. It exists as part of the flow of changing human circumstances, containing its own complex history and its own resolution, even as it is part of the larger fabric of art, which has its own periods of calm and culminating contrasts.

Everyone in the art world or related to it has at least one requirement: he must call the shots as he sees them. Acceptance through fiat—or the prevailing conformism of today—can serve only to destroy the artist's ability to grow. To be tolerant does not mean that one needs to accept everything. Only integrity, even when misguided, can lead to freedom.

The artist may well feel apprehensive at the role of the marketplace today, for art is not stock to be manipulated for profit; nevertheless, the professional artist is inevitably involved with questions of sales and prestige. It is not easy in this environment to keep one's bearings amid the chaos of ambitions, claims, and counterclaims. To do so, however, is all-important.

The student or creative artist needs to know that he can and most probably will be fallible. But he should nevertheless decide all questions for himself.

Theory

Many artists distrust theory, or indeed all intellectualization, for to them theory creates prisons. They want no bars to their ideas or sensibilities; even their own past practice seems suspect to them as they seek for fresh starts. But can the artist completely dismiss thought, its generalizations and influence? Is mind ever separable from sensibility? It may be hidden in automatic habit or disguised as feeling, but it is always present.

Though a painter must paint, he is not simply a painting machine. He is a person with as varied interests as those of other persons, and it is he who should have most to contribute not only to the practice of art but to its theory. He may not solve the situation in which he finds himself, but he can make some sense or even nonsense of it. Either of these—even the nonsense—can become a point of departure for better ideas.

Contrasted Viewpoints

Much has been written and spoken about art. But theory, like practice, requires reevaluation and change. In the discussion that follows we will find

it useful to retain several terms long current in aesthetic literature and to focus upon those that most sharply oppose one another. Four such terms are *classicism, romanticism, naturalism,* and *realism.* They contradict even as they influence and permeate one another.

These four terms stand for tendencies that seem always to have been present in life and art; contemporary art, indeed, is a vast panorama of their action and counteraction. Although in real life their manifestations are complex, here they will be defined in terms of their basic differences. And before they are discussed in regard to their role in art, they will be related briefly to their broader ideological setting—to the world of reality, made up, as we have said, of particular objects and our ideas about those objects.

The classicist, the first of our four groups, would point out that what we have called an object has only a temporary existence while the *idea* of an object can be immortal. The idea of an object, he would say, must precede the object's birth, and while the object is inevitably imperfect, the idea can be pure or perfect. Since ideas are permanent they are therefore not only preferable to the object but more real than it. The so-called object then becomes but a shadow of the idea, which is the *real* object. Our senses thus deceive us. Our goal should be the perception of the real world of essential ideas and their relationships and, for the artist, their expression in art.

Others—the romantics—would say that all we know of particular objects are precisely our sensations of them. Knowing only complex sensations, we can be certain neither of the objects nor of any absolute idea of them. We are sure only of present passing sensation within ourselves. All is relative; there are no certainties. What we usually consider to be a material object becomes a group of personally felt sensations or personal or subjective ideas of the object.

Still others—the naturalists—would indicate that all ideas as we know them are personal, human, subjective, and therefore untrustworthy. The material world precedes any human idea of it. To understand that world we must divorce it from as much biased personal perception as we can. We must clearly observe and measure its relationships, which are physical and mechanical. Material experience is a labyrinth of cause and effect, of physical action and reaction begun by some first mover who set the whole chain of events into motion. To this group the material object is real and our ideas of it are but reflections of our experience with it.

Other materialists consider this mechanical emphasis too limited and reductive, in that it accounts neither for the various complexities of levels of reality nor for the transforming role of human ideas or consciousness. To this group, material experience or the object comes first, but it is the object in terms of our ideas of it. The forces of reality need not be set in motion but inevitably move as internal oppositions act upon one another. Reality is many-sided and consists of interrelated and interdependent levels of increasing complexity, all constantly undergoing change. Continuous small changes eventually result in rapid, more complete transformations. In art this point

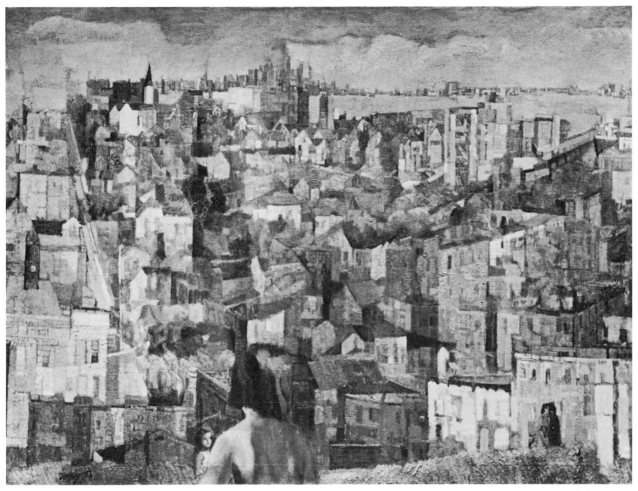

Collection of Staten Island Museum. Photograph, courtesy of The New York Times

PLATE 1. STATEN ISLAND

Classical influences: rigid geometric architectural order; vertical and horizontal
movements; repeated rectangular shapes; triangular opposition; circular countertheme;
part closely designed within whole; spoke shape pattern opposing rectangular.

Analytical diagram

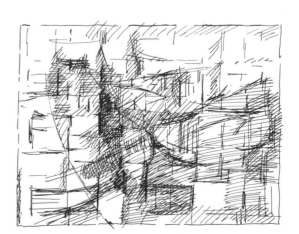

of view would penetrate appearances and express the richness of reality in a synthesis of thought and sensibility. Such an art is called realism.

In experience, of course, manifestations of these points of view are complex and one or another may be present where there is no philosophical awareness of it: a work may be analyzed, for example, as classical if its prevailing aspect is that, regardless of the artist's intention. In addition, a work may show more than one of these tendencies at any time; the same work, for instance, may well have both romantic and naturalistic aspects.

We will now look at each of these four tendencies as they are specifically related to the world of art.

Classicism

The classicist is concerned with a hierarchy of absolute ideas which are the essence of truth for him whether in life or in plastic relationships. Though the source of such ideas is outside him, the human being possesses those ideas because he is an expression of them; like a fragment of a prism, he reflects the whole.

Just as the individual is born with all knowledge and needs only to recall or deduce what is necessary, so to the classicist the painting already exists in some ideal form. The painter merely gives it material or impermanent existence.

Every culture has had repeated classical manifestations in art, inventing its own system and producing works in which each part is fully designed and indispensable to the whole. The appearance of such works may vary from one culture to another, but each possesses a high degree of organization, a common vocabulary, social symbolism, and shows a stress on geometric and other primaries and on completeness.

The balance for such works is stable; tensions are reconciled within and to the frame; line binds clear shapes that exist in a defined pattern. Such work is architectural, a synthesis of ideological and plastic elements.

Among the artists of classicism are Poussin and Ingres. In its contemporary striving for the very essence of purity, it produces a Mondrian.

Romanticism

The romantic, sure only of his own present sensations and feelings, finds no knowable reality and adopts no system. A stream of intuitions from his innermost being guides his work. Such work must be done rapidly, before the feeling or inspiration vanishes; order is achieved through a moment of realization caught on the fly, the bare point of order. Truth for romanticism is relative, yesterday's truth disowned today.

Romantic art thus runs the emotional gamut; it is highly poetic, an art of individual protest or celebration. Romantic painters distort or use plastic contrast for psychological purposes as they extract images of feeling states or mood. Some concretize dream fantasies, pursuing the irrational or probing subconscious or unconscious areas. Structure evolves mysteriously, held in

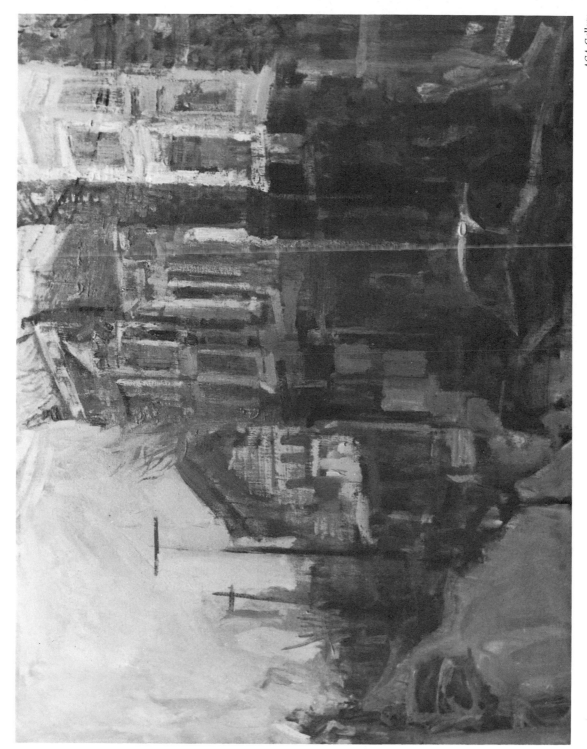

PLATE 1A. BIRTHPLACE

Romantic influences: distortion of stroke for psychological purposes; fluid movement, merging and less defined shapes; dramatic climax.

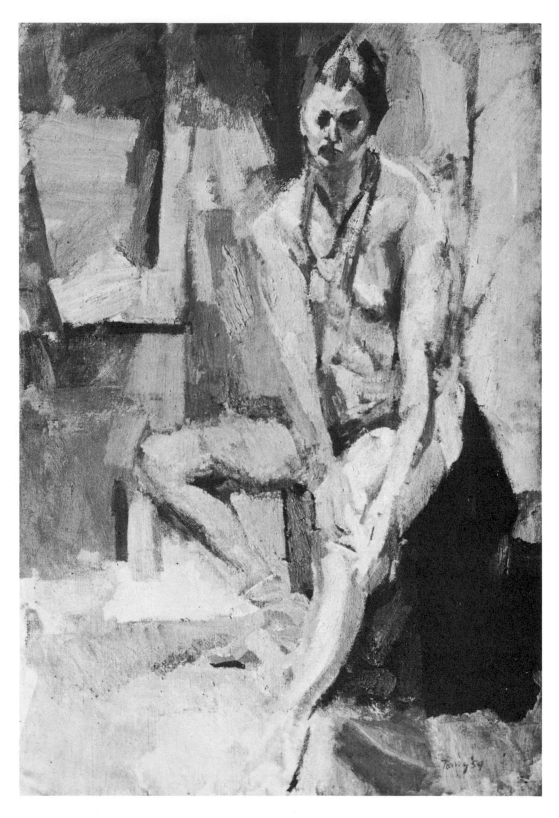

PLATE 2. WOMAN WITH YELLOW STOCKINGS
*Naturalist influence: plastic structure derived from study of model's appearance;
specific light; limited distortions in proportion used mostly for emphasis.*

equilibrium by the climax; the latter dominates the form, which is fluid, open, calligraphic. The work is marked by mergings, disappearances, sudden surprises, with stress upon unexpected pattern and movement in space.

Through its experimentation with materials and techniques, romanticism has nurtured inventiveness but also showmanship and faddism. In our own sympathetic times, the lonely romantic is all too often surrounded by others, and what began as an individual protest becomes an academy.

Romantic painting includes that of the mannerists, painters of the baroque, the expressionism of Van Gogh, as well as modern-day abstract expressionism. Its painters range from Rubens and Delacroix to Klee.

Naturalism

Truth for the naturalist lies in correspondence to measured fact, regardless of one's feeling or preference. He trusts only observation and measurement, reduces what he sees to mechanical relations. In naturalistic art, theory vanishes into practice, and the particular appearance conditioned by specific time and place becomes the whole painting.

Two possibilities exist for the naturalist: he can seek the illusion of particular appearance, or he can turn relative distances and ratios into formulas that become mechanical abstractions.

Naturalism has been a rich influence that periodically disrupts or enriches classicism and romanticism. As expressed in impressionism it becomes a source of renewal, a catalyst that led to wide-ranging experimentation. At its best it produces a Velásquez, a Monet, or a Pissarro.

Realism

For realism, the illusion of the naturalist becomes only one facet of a larger symbolic structure. Realism is as concerned with truth as classicism, but with a truth that is relative as well as absolute, since reality is seen to be in constant flux. The individualism of the romantic becomes for the realist a personal path to socially meaningful experience.

To the realist the painting is real in that it consists of canvas and paint and visual forces that move the sensibility, and refers to the larger reality from which it stems. The parts making up the whole—object or subject, matter or mind, content or form, practice or theory—are inseparable; change in one changes the other.

The organization of realist works of art is as whole as it is for classicism, but the relationships contained are not preordained but are torn fresh from the fabric of life itself. The climax that dominates the romantic work becomes for the realist a logical fruition of the progression of visual ideas; any synthesis comes out of a social rather than a simply personal present.

Making a work includes for the realist study and evaluation, the extraction of discoveries on all levels of experience and thought. The environment sets up the conditions, but the conflict within thought provides the forces that

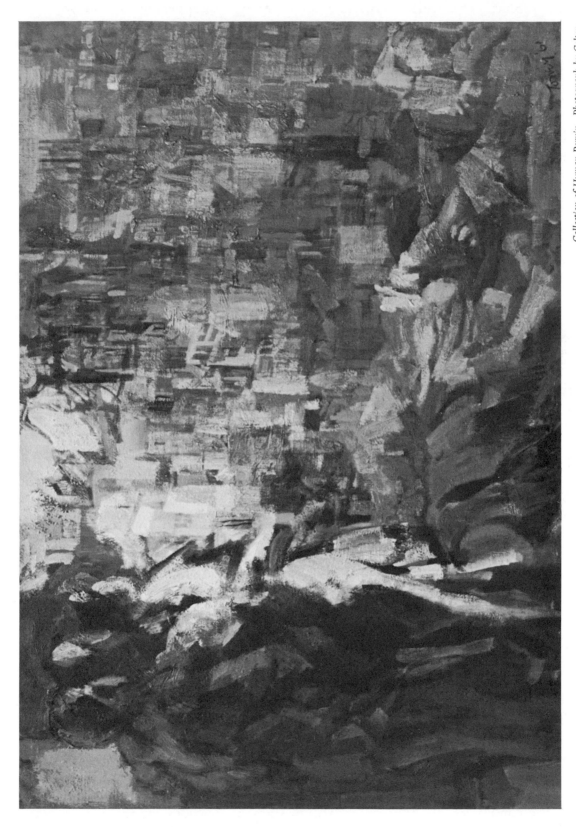

PLATE 3. THE WINDOW

Realist goals: symbolic image generalizing artist's perception of reality; penetration of appearance to reveal many-sidedness of reality; plastic structure derived from ideological; closely designed architectural structure.

motivate the new work. A complex work will contain many opposing forces, the main forces influencing the others and each force having dominant and subordinate aspects. Counterpoint between these causes movement; the stronger contradictions establish the main character or direction of the work.

Since time to the realist is not preconceived timelessness but a present with a past and future, each painting is a momentary resolution within a constantly changing development. Changes in the artist's life and ideas will force new beginnings; one painting will inevitably lead to another.

The realist is at once alone and of the group, his partisanship that of alignment with others, based on social awareness toward the good of the whole. His work becomes his means of expressing his discoveries about himself, humanity, nature, and painting itself. His constant search is for awareness and understanding.

Realistic painting of the past has produced artists like Caravaggio, Goya, Chardin, or Eakins. Modern realism, however, cannot be that of these painters but must embody the extension of awareness unearthed by contemporary art.

Synthesis

In actuality we each contain, not one or another of the above formal views of reality, but many conflicting points of view, born of our complex experience in a particular environment. Our ideas of reality change constantly. While great art can be created regardless of the prevailing view of reality, such a view will nevertheless affect the kind of discoveries the artist will make and the form of expression his work will take. Art results whenever a profound experience and discovery become embodied in a concrete whole structure.

Often the student, in attempting a synthesis, will become merely eclectic, adding one point of view to another without much conviction. Such eclecticism is paralyzing; with equal points of view canceling one another out, the eclectic is unable to move in any direction.

It is possible, however, that greater clarity as to the nature of the main cleavages can help the student to untangle his contradictions. For this reason we turn now to a brief outline of the creative process, an outline that will be expanded in the remaining chapters of the book.

CHAPTER II
THE CREATIVE PROCESS

Each of our four competing traditions has its own explanation of the creative process. Two of them, classicism and romanticism, center upon the sudden flash of insight—the type of moment we are all aware of when we seem to get an answer, seemingly out of nowhere, to some problem important to us. For classicism this is the moment of revelation, its source some absolute power beyond but containing the human being. For romanticism each intuitive flash is one of a stream of inspirations coming mysteriously from the depths of the individual.

Curiously, classicism in its search for absolute truth soon erects a solid structure that codifies and interprets each subsequent revelation; to avoid heresy, revelations become preserved in and subordinate to static traditions. The romantic, proudly heretical, claims each insight as his own; he accepts no authority outside himself.

The other two traditions are suspicious of both these sources of revelation. The naturalist prefers clear observation to the mysterious hunches of the classicist and the romantic. The realist considers inspiration as the bursting into consciousness of a pattern suddenly recognized as significant; it is a natural phenomenon, part of a larger process.

Much interest has of late centered upon the anatomy of the process of invention. Certainly for the artist, and particularly the student, an awareness of the pattern of events necessary to creativity can help to build confidence, patience and perspective.

My own experience as a painter and a teacher has convinced me that there is indeed such a sequence of events and that an awareness of this sequence on

Problem:
individual's
resources of
experience;
biological and
cultural
heritage

Exploration

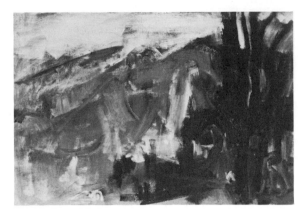

Levels of awareness
sensibility
association
symbolism
illusion
structure

Perception

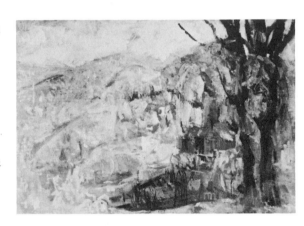

Plastic language
elements:
line
shape
value
space
color
texture

Conception:
generalization
cross-fertilization
insight

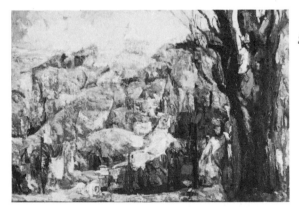

Social test:
friends
commerce
galleries
museums
technology
education
history

Objectification:
thematic sequences
pattern
rhythm
climax
equilibrium

ACA Gallery

PLATE 4. The Creative Process
The creative process is a continuing transformation of material experience into
discoveries which become a new reality leading to new discoveries. The completed work
is a pause in the continuing transformation.

the part of the student will enable him to gain in patience and work more boldly. He learns to accept a building concept of work, to establish layer upon layer of paint. Words alone, of course, do not tell the whole story of the creative process; the student discovers its true ramifications only through actual work. Nevertheless a discussion should prove quite helpful.

Dewey, Whitehead, and others have found it useful to break up the creative process into successive steps. According to one such notation, five interweaving levels of activity make one another possible. There is (1) the awareness of a problem, then (2) its investigation or perception, out of which come (3) conceptions as to its nature and their concretization, (4) objectification or realization into an actual work, which is finally (5) socially experienced and tested.

Many—to begin with the first step of the process—do not like to think of painting as a problem. They come to painting for other reasons. I often smile to myself when they say they have come to it for relaxation. It is not that painting does not have its recreational aspects, but that any activity so closely involving growth, development, the need of discovery and judgment, gets its fair share of anguish. One cannot become a painter simply by learning a sequence of actions, achieving a skill and exercising it. One must go through the level of expressive achievement that makes possible the next level.

Nor can one start with the solution or end result. How presumptuous many of us are when we become discouraged that our beginning strokes do not automatically have the look of recognized masterpieces! We make a few strokes and look in vain for the magic. The New York area alone is full of students who make the round of the teachers, seeking the key that will guarantee them success.

To become a painter, or indeed any other kind of creative person, requires a lifelong development and dedication. Painting is an act of transformation not only of paint but of the individual doing the painting.

Motivation : Levels of Significance

The painter's "problem," of course, is simply a convenient symbol for his motivation to paint or draw. He may wish simply to duplicate a scene that delights him; he may have been commissioned to do a portrait. Since painters are visually oriented, it is most likely that the very contrasts of light and dark of color and texture will motivate him. Such visual contrasts function on a number of levels which should be appreciated before the first step in the creative process can be understood.

There is, initially, the physical effect of such contrasts on our *sensibility*, which is wedded to a mélange of psychological *associations*. Also these visual structures can be used in a painting as *symbols*—either directly, as in a portrait or a person, or as abstracted generalizations, as when a circle stands for the life cycle.

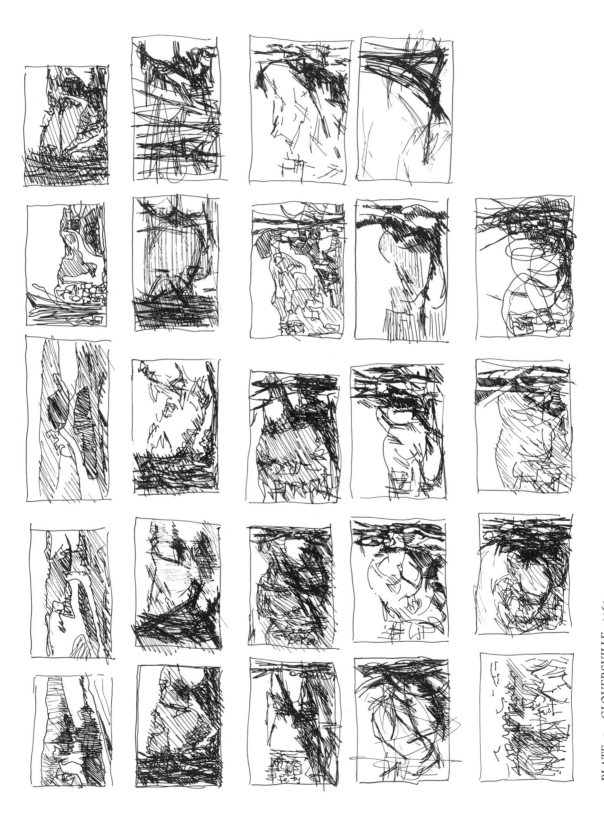

PLATE 5. GLOVERSVILLE, 1962
Thumbnail sketches in which a familiar view is conceived as a huge reclining woman pierced by a symbolic tree that is simultaneously a woman and child.

It is possible, however, also to manipulate visual contrasts so that they look like something in real life—to create the *illusion* of something that is not there: a landscape or a nude. To attain this level requires knowledge of the things or relationships duplicated; it can become a path to discovery about nature and life.

Finally, a plastic work, to be whole, must have its own *structure*, a unique set of relationships of visual contrasts that achieve organic oneness.

The painter embodies all or many of these levels, at various times emphasizing one or another. The Gothic period in art was highly symbolic, naturalism often highly illusionistic. The stress of the painter will depend upon his motives at the time of painting.

Perception of the Problem

The first stage of the creative process, that of searching out the nature of the problem, is usually marked by a high degree of spontancity, improvisation, bold constructive and destructive phases. In this, the "fun" period of the painting act, the painting is open, free for anything; we work automatically yet analytically. We need the freedom to tear the problem apart, to try out many combinations. Even this freedom is limited by past habits, but we can at least seek to establish wide-ranging flexibility.

In passing through this phase the creative process moves from *physical freedom* to the *freedom of knowing* what is necessary to the problem. Physical freedom is important in the first stage; the second stage, that of freedom of knowing or conceptualization, is characterized by the deepest anguish and the deepest satisfaction.

Conceptualization

At the conceptual stage of the creative process three processes evolve: *generalization*, or the level of order; *cross-fertilization of ideas*, the level of invention; and finally the flash of *insight*, or the level of judgment. Together, these contribute the substance and form of the work.

The artist makes visual generalizations as he becomes conscious of the similarities and differences of visual contrasts and stresses one or another. These congruities enable him to discern possible order.

Secondly, as he interweaves the variables, hybrids occur which present fresh insight into reality. This cross-fertilization results in invention or discovery, an imagined or new form.

Finally, in the shifting of pattern sequences that accompanies the artist's many trials, one sequence will occur which the artist's personal level of awareness is prepared to recognize. When this occurs and the pattern is snatched into consciousness, a flash of insight is said to occur.

These three processes occur together. One's insight is into the qualitative significance of the cross-fertilization of generalizations that integrate the

A. *White of canvas covered with sienna thinned with turpentine to provide neutral ground.*

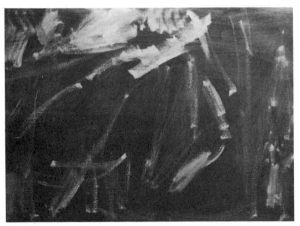

B. *Broad lines of initial value contrast boldly brushed in with white.*

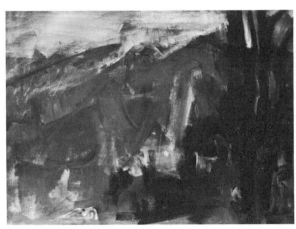

C. *Darks as well as lights further define idea; landscape broadly established.*

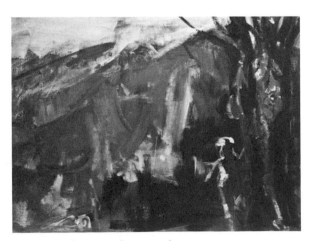

D. *Figure idea strongly asserted.*

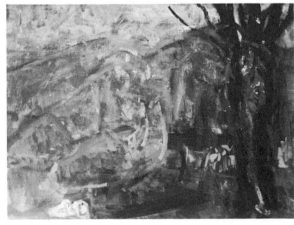

E. *Further exploration and elaboration of panoramic vista into possible value and color ideas.*

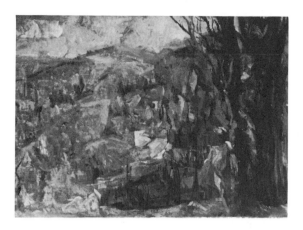

F. Exploration of large rhythms and elaboration of panorama details.

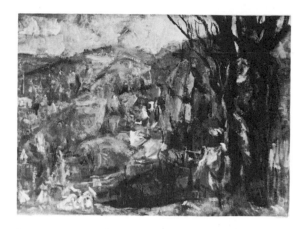

G. Investigation of geometric recurrent rhythms within larger framework of contrasts.

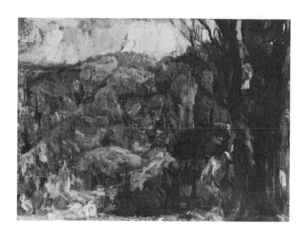

H. More subtle weighing and manipulation of value and color relations.

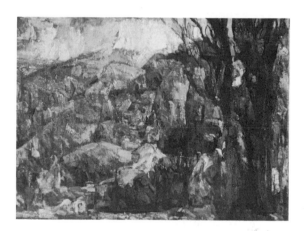

I. Clarification and simplification of patterns; subtle adjustments of plastic forces.

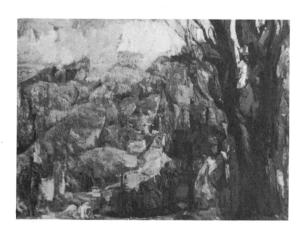

ACA Gallery

J. Patterns clarified and strengthened in final assessment of relationships. Canvas is counterpoint of vertical repetitions vs. oval, circular rhythms, and rectangular vs. circular shapes. Triangular subordinate idea allows opposition of spokelike pattern as diagonals crisscross. Climax at upper right of center; balance asymmetrical. Color is a progression of reds and blues, subordinate grays and whites, counter idea of green.

various levels of the painting or drawing: sensibility, association, symbolism, illusion and structure.

Objectification

However important the period of conceptualization may be to a painting, it does not become a work of art until it achieves objective existence, until it becomes an object in itself. It may be said to be an object in two ways. First, a painting is material that can be touched, lifted, put together, and taken apart. Second, it is an object in terms of the physical nature of the forces that the relationships of line, shape, color, texture, value, and space become. These contrasts make themselves felt as light rays of varying impact, but if they are to possess coherent meaning they must have structure—organization.

To achieve such oneness, the elements named above will be organized into thematic sequences of main, minor, and opposition ideas, each progressing through the work with variation and reaching main and minor climaxes. A color and value pattern, rhythmic repetitions, as well as the main climax, help hold the work together. The contradictions in the work are thus resolved into a dynamic equilibrium through the orchestration of the various forces. Only then does the work of art become a new reality.

Social Test

No work is complete until it is shared with others. The individual can go far afield in his discoveries, the symbolic structure of the work lose all sight of its moorings in reality; but through a public viewing of the work it can be tested through the experience and sensibilities of others. Such a viewing does more: it elaborates the work, alters the painter's consciousness, and helps determine the next work. The social test thus sets into motion possible cross-fertilizations that help break rigidity of habit, and is consequently an important part of the creative process.

We shall have more to say about each of these creative stages in Parts II and III.

Conclusion

The elaboration of the format suggested in this chapter will become our means of exploring the problem of developing as a painter. Such an analysis will become useful if taken as a means to an end rather than as a dogma.

No pattern, of course, can approximate the multiplicity of what actually happens in painting. In reality, few artists work on only one painting at a time; most work on many things and move from work to work as they get ideas. The process may begin and reverse itself many times as the painter gains or loses interest. He may never get beyond the investigative stage; he may work haphazardly or in an organized manner. Much, therefore, depends

Photograph by Eisman

PLATE 8. Social Test

upon the habit structure of the particular personality or the objective of the particular situation. The creative process can be stunted or frustrated as well as it can be encouraged. Failure, nevertheless, can lead either to further failure or to a more profound success. As the artist is forced out of accustomed habit patterns, he may find new kinds of solutions.

PART II
THE ARTIST'S RESOURCES

CHAPTER III
THE STUDENT

After a lengthy classroom discussion of one or another aspect of painting, there is sometimes the plaintive or humorous query, "But how do you paint?" It is the age-old question—how to paint. Many students come expecting to be taught a fixed technique or even many techniques with which they can then express themselves. But technique is inseparable from the images it forms or the feelings it arouses. Technical skills grow in a developmental process of interacting theory and practice—not one skill at a time, each perfected, but rather the raising of the whole problem from one level to a more complex one. Each aspect develops throughout life not separately but as part of a whole.

If there is one key word for good technique, it is *patience*. Simply waiting will allow the paint to dry enough to permit succeeding layers. Simply waiting will allow time for ideas to come, for the creative process to work. When in doubt, one can be confidently patient.

Sometimes students will come hoping rapidly to acquire a skill that can be turned into money. There is nothing wrong with such a professional goal, but they should realize that it requires time. More often students are concerned about their abilities, and for that reason I avoid such words as "talent," which imply static concepts about which nothing can be done. The already insecure student is only too willing to assume lack of talent when difficulties accumulate, though these may be the very sign of growth.

Most students in the classroom are romantic in outlook and highly individualistic; others copy only what the eye presents. Some bring a sense of organization, few a consciousness of an ideal order. Many are confused,

PLATE 9

Class at New School *Photograph by Peter Moore*

Workshop Class in Katonah

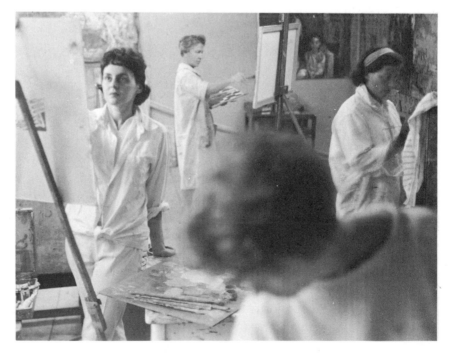

simultaneously seeking opposite goals—independence and dependence, freedom from interference and a demand for more direction. The instructor must be aware of all these contradictions and exercise an interplay of spontaneity and reason as he attempts to provide meaningful support. It is inevitable that success and failure will be intertwined.

Persistently the gap between the student's aim and his readiness must be dealt with, especially as created through one-sided development. Students with excellent backgrounds of art history and developed taste are often the merest beginners in workshop practice; they become destructively impatient with their fumblings and demand solutions when they are barely beginning. The gap between aim and readiness paralyzes the creative process.

The creative process, subject to every kind of external and internal pressure, requires time, and unfortunately the classroom is hardly set up to accord with its needs. It cannot be imprisoned into so many weeks or hours or made to go through its paces; nor are our living situations so ordered.

Each student, furthermore, brings to the classroom a distinctive body-mind complex and a unique situation in life. Our circumstances bear greatly on our creative possibilities.

The instructor must be aware of all these challenges and try to meet them constructively. Often the contradictions within the student will reveal themselves not only in the painting act but also in classroom discussion. The instructor's ideas, echoed back by the student, will often seem almost unrecognizable. Yet it is precisely this distortion which the instructor must seize upon to be able to understand and help the student. One must endeavor to go behind the masks of misunderstanding to the underlying reality.

Oddly enough, the student can help in this regard, for he brings his own way of seeing, a way that is no more static than the instructor's. In this fluidity it is necessary to have a solid base, a set of concepts against which differences can be tested. This will help give direction to the discussions and prevent a destructive fragmentation. The point of view chosen should be rugged enough to withstand individual assaults without being dogmatic.

Often a teacher, faced with a "homogeneous class," will be tempted to adopt a stereotyped approach. It is far better to be aware of the many layers of development within the classroom and the mélange of cross-purposes shown there and to deal with them together or separately.

Viewed in this way, the classroom will be seen as an arena where vague longings, tenacious hopes, determination, tentative trial, boredom, fascination, romantic illusions, compulsion, frustrations, search for fulfillment are pitted against confusion, fatigue, pressures, conflicting interests, variable weather, illness, unsympathetic criticism, slow development, creative anguish, contrary standards, and the many tensions in today's world.

Despite all these handicaps, delayed careers do get new starts. Hobbies are gained and relaxation and satisfaction are achieved by many. On the school bulletin board it is a commonplace to see announcements of shows by former students.

CHAPTER IV
MATERIALS

The classicist may say, "In the beginning is the idea," but the realist insists, "The idea springs from material experience." For the painter "material" means paint, paper, or canvas. It also means the material of his life, of nature and society, its culture and technology. The work of art is a synthesis of all of these, expressed in plastic materials.

Material should be appreciated sensuously. I had a student once who was allergic to oil pigments, an impossible situation for one who wanted to work in oils. Fortunately, our choice of material is widely expanded today. There is immense satisfaction in the feel of the qualities of paint, its smell and sight, whether thin, thick, runny, flat, or raised. Respect paint for itself and not simply for its services. Its contrasts have great power when controlled by an artist.

Paint has flexibility; it is plastic. It can be brushed opaquely or transparently depending upon how much oil or other medium has been mixed with it. It can be applied dryly. Thin or thick, it can be dripped, dropped, blotted, scraped, knifed, rubbed, wiped, or engraved. It can be caressed or brutalized, put on tenderly, delicately, boldly, passionately, in small dots, thin washes, short or long strokes, in a series, in large flat planes, in slabs. One layer may succeed another, obliterating or modifying it. One can paint on a canvas for years without destroying its flexibility or increasing dangers to its permanence, provided some few relationships are observed. Today painters have found many new ways of using paint and particularly of combining it with other materials such as sand, paper, cloth, and other substances.

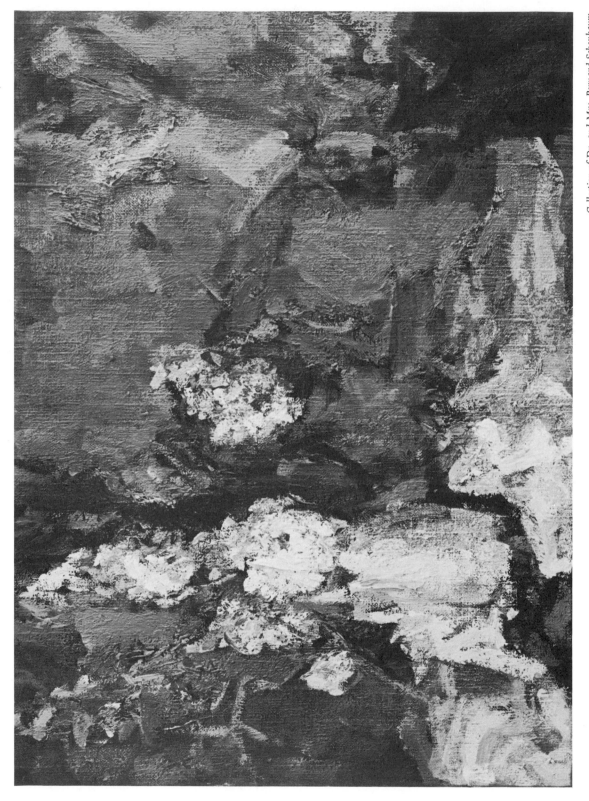

PLATE 10. FLOWERS

Material should be appreciated sensuously. There is an immense satisfaction in the smell, sight, and feel of the qualities of paint.

WOMAN AND CELLO

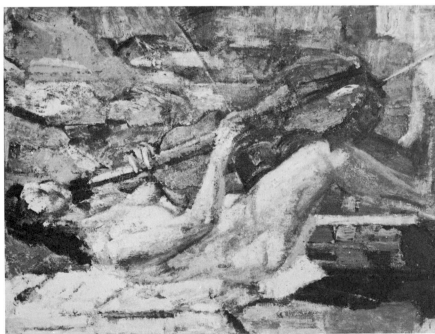

RECLINING NUDE WITH BLUE AND RED DRAPE

PLATE 11
There is no one technique. One may paint with calligraphic directness or build with thin washes or glazes over dry underpainting. Opposition brings out each other's qualities, but use on same canvas requires coherent relationship.

There is no one set technique. Students are often confused when they have received contradictory advice from the same or different instructors. They should remember that in materials and techniques as in the whole process, development comes out of the action and counteraction of contrasts.

There is wide variation in what is possible in paints. One may paint with calligraphic directness or build with thin washes or glazes over a dry underpainting. The use of such contrary methods will serve to bring out each other's qualities, though their use on the same canvas will require a coherent relationship. Here and elsewhere you will be making technical discoveries all your life.

The paint itself, finally, should be used with variation even when a relatively uniform texture is desired throughout the work. The textural orchestration of paint can have as great a significance for the finished work as can any other element.

Pigments

I use and recommend a simple combination of pigments; others differ. André Lhote suggests using as many colors as possible, using them purely or only with white in order to reduce the instability that comes from mixing. I prefer a simpler combination called a cadmium palette—a small group of primary and secondary colors, either cadmium or stable with cadmium. Limiting the variety of pigments makes the student more aware of the basic role of red, yellow, and blue in all mixtures.

On the palette I recommend, warm and cold yellow, blues, and reds are for convenience buttressed by secondary and some earth colors. With one exception the yellows and reds are cadmiums, the exception being alizarin crimson. The blues are ultramarine and phthalocyanine.

Colors are said to be warm as they move toward red or orange, cool as they move toward blue-green. Among the blues on the palette, therefore, ultramarine is warmer, phthalocyanine cooler. Since yellow becomes orange-like as it gets darker, while red approaches orange as it gets lighter, the rule among the cadmiums is that the lighter the yellow, the cooler, while the lighter the red, the warmer. As red cadmiums get darker they act as if they contained both blue and yellow. It is for this reason that alizarin is necessary, for it supplies a purplish red that does not gray in mixture with purplish blue, or ultramarine.

The earth colors on the palette are useful for tonal painting and for early stages in a work, as in underpainting. Of these, the siennas are lighter and warmer browns than the umbers; in both, the burnt form is warmer than the raw. Venetian red is a reddish brown, lighter than the somewhat similar Indian red I sometimes use. Yellow ochre completes the earth group.

While the earth group and cadmium group are stable chemically with one another, the different drying rates of each need to be considered. The earth colors dry more rapidly than the cadmiums, but dry consistently among

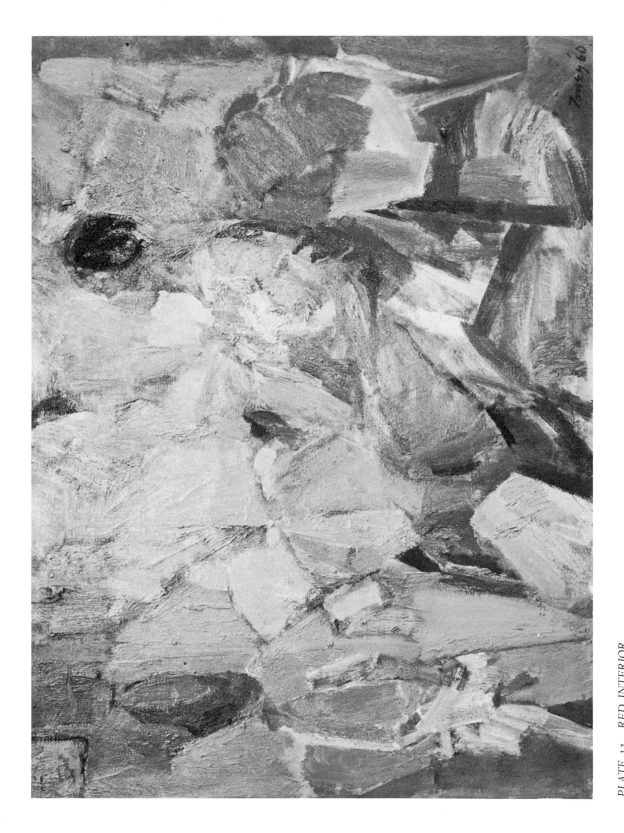

PLATE 12. RED INTERIOR
Paint itself should be used with variation even when a relatively uniform texture is
desired.

themselves and with lead white. Alizarin and phthalocyanine also dry more rapidly than the cadmiums.

With the above pigments I mix titanium white except in underpainting, when the more rapid-drying lead white or underpainting titanium whites are more appropriate; for transparency I use zinc. I also use Mars and ivory black, although infrequently. We will have more to say about specific colors in Part III.

Mediums

A medium is the liquid with which pigment is mixed to prepare it for application. It is possible, through controlling the use of a variable in the medium employed and through careful mixing, to control the rate at which paint dries. In oil painting this variable element is gum turpentine; in other types of painting it might be water. The rule for drying rates is that the more of the variable (turpentine in oil painting), the leaner will be the mixture and the more rapid its drying.

This is especially important in preventing cracking in a painting. To prevent such cracking, it is desirable that the layers nearest the canvas dry more rapidly and that each succeeding layer dries more slowly. More turpentine should therefore be used in the medium for initial layers, and the medium should become richer, with less turpentine, as the layers proceed. The principle is very simple, but its application can be quite complicated, especially as the pigments do not all act the same. Further compensation can be made by mixing faster-drying with slower-drying pigments. Where a relatively pure fast-drying pigment is desired in an area, one must make certain that a slower-drying one is not underneath. Time itself will be a factor in this. The more time allowed between layers, the greater the possibility that lower layers are drying at a faster rate.

It is relatively easy, therefore, to control the chemical relationships when a picture proceeds through a series of planned stages. If the entire erratic creative process occurs directly on the canvas, control can become much more difficult.

In oil painting I use a medium consisting of one part Venice turpentine, one part damar varnish, one part stand oil, plus the variable of 9–5 parts pure gum turpentine.

This same medium may be altered to become any of the following: stand oil with gum turpentine; stand oil and damar varnish with gum turpentine; linseed oil (sun-thickened or regular) with turpentine; and even damar varnish with turpentine. There are many other mediums as well, and plastic paints introduce still further modifications; the basic principle of mediums, however, remains the same. Sooner or later, the student should read one or more of the many books available on materials.

To all artists, of course, permanence is not important in painting. Romantics in particular, with their stress on the present moment, tend to dismiss the question in their need to follow inspiration and make fresh com-

binations. Sometimes, therefore, very fragile materials are used, and it is not unusual today to find freshly painted canvases cracking. The beginner should be aware of this problem without letting it interfere with the painting act itself.

Binders

Binders are not to be confused with mediums, though they sometimes are the same thing. The binder in painting is what holds together the powder which is the chemical color. In various media the pigment will be the same while the binder will differ. Watercolor, for example, may be formed by the use of gum arabic, casein, egg, and recently, plastic substances. Egg binders and plastics such as Liquetex make paints that use water but resemble oil paints yet are very rapid-drying. The great mural artists of Mexico—Siqueiros, Orozco, and Rivera—popularized the use of plastics, of which there are now various formulas modified by plastic mediums plus turpentine or water. Egg and wax emulsions and such ancient crafts as mosaic, stained glass, and enameling have also been strongly revived. Some of the experiments with materials have included the use of commercial paints such as enamels.

Each of these media offers particular advantages. Transparent water-color is inevitably more spontaneous than the others, with a premium on freshness and varying use of the white of the paper. Egg tempera offers an extremely flexible means for subtle control, combining transparent and opaque qualities. The new plastics offer other advantages, especially for large murals. Their rapid drying rate is a convenience, though it may destroy certain forms of flexibility, and greater permanence is also claimed for them. While this book will be concerned primarily with oil painting, the general discussion is applicable to all media.

Canvas, Brushes

Paint can be applied to a variety of surfaces, including canvas, wood, composition panels, canvas boards, paper, plaster, and so on. Permanence is again a factor in many choices, as are the practical demands of the situation. My own preference is for linen canvas, though a good grade of cotton is better than poor linen. I also paint occasionally on composition panels and paper.

Properly mounted, rag paper can be as permanent a surface as any; and where economy is desired in the early stages of one's development, painting on paper with at least some percentage of rag may result in a bolder, more experimental approach. Of course, if a good rag paper is used and then mounted, the economic difference disappears.

Linen canvas, the choice of most painters, combines the advantages of strength, relative permanence, and flexibility. Its weaves are variable. For most purposes I prefer a close weave of medium texture; however, a fine surface is desirable for certain kinds of portraiture, particularly where the weave of the canvas may intrude in unwanted ways.

For many years I prepared my own canvases, sizing them first with a coat of rabbitskin glue, allowing them to dry, and then applying one or two coats of priming with a lead white, a rapid-drying flexible pigment. I also prepared gesso panels. Eventually I abandoned this practice when it became clear that my situation did not permit canvases as good as those I could purchase ready-made. Some experience of this sort, however, is valuable if only to make one more aware of the qualities of the material and processes used. Many painters are now sizing and priming their own canvases either because of their need for enormous sizes or for reasons of economy. Others sidestep all preparation completely.

Canvases are prepared for two reasons: first, it is necessary to separate the painting from the linen; secondly, one must provide a less absorbent surface than that of the untreated canvas. If oil and turpentine were applied directly to the unsized canvas, they would permeate the weave and hasten deteriorating chemical actions. Glue size, therefore, is used to provide the needed separation of painting and canvas; and the priming with lead white serves to reduce absorbency.

Canvas is generally stretched on wooden stretchers. Unfortunately, the usual stretcher purchased in stores tends to be made of green wood and in any larger size readily warps. For canvases above 40 inches it is usually necessary to make larger, heavier frames with crosspieces. Today it is becoming increasingly common for artists to paint on unstretched canvas, particularly when the canvas is so large that it must be rolled before one can get it out of the studio and into the gallery. Once in the gallery, such canvases can be stretched on appropriate frames or other hanging devices may be used.

Stretching a canvas is an intricate operation. After ensuring that the stretchers are squared, the principal requirement is to tack down the center of one side (usually the upper side), halfway between the corners. Then move to the lower side, where the same thing is done. Again, for the right- and left-hand sides, tack down the center of one section and proceed to the opposite side, and similarly for each subsequent division in a regular procession until completion. The corners are tacked down last. Instruments that pull the canvas tight are helpful, but more important is evenness of pressure.

Another problem with canvas is its expansion and contraction with humidity changes. The more moist the environment, the greater the expansion will be; the drier the air, the tighter the contraction. Corner wedges are sometimes useful for tightening or relaxing tension. Unless the changes are extreme, however, it is preferable to learn to accept such variability with equanimity, rather than worry the canvas continually with tightening and loosening. The ideal situation for canvas is one of moderate dryness and moderate temperature.

Brushes should be chosen to suit one's purpose. If you wish to paint in broad wide swaths, the house painter's brush is useful. Much of the time you will find a large flexible long-haired bristle flat-hair brush the right instrument. (Flexibility here means that the bristles yield to pressure but snap

back to their original position when released.) For even greater range of touch, a large red sable or sabeline round-hair brush permits you to obtain the tiniest detail with its point or chisel edge, while being useful for sensitive broad glazes, dry brush layers, or simple calligraphic directness of stroke. The red sable or its imitation sabeline should snap readily to its original position and to a point.

Use large brushes for large areas and smaller ones for detail. Vary your strokes since the same size of brush stroke throughout produces an intrusive equality. While only a few brushes are absolutely necessary, you should have enough so that if you wish to counterpoint color oppositions you need not keep washing out the same brush. Too much washing with turpentine tends to make your brush brittle and stiff and less responsive to subtle changes of pressure. Most beginners are too preoccupied with detail and buy far more small brushes than they need.

Wash your brushes whenever there is going to be any lengthy period of time between use. Otherwise take out most of the paint with turpentine or varnolene and allow the brushes to lic flat in a linseed oil solution. Since prolonged pressure on the brush point leads to permanent distortion, stand brushes not in use upright, brush end up.

Your remaining painting material needs are few. You must have a surface on which the paint is mixed, called a palette, and the instrument for controlling its surface, a palette knife.

The palette knife, in addition to serving as a scraper, may also be used as a paint applier. If you use a palette knife for painting, however, keep your surface varied. Avoid the deadliness of an insistent method. The palette knife is useful for areas of flatness of varying thickness as well as in obtaining the richness of surface that can be achieved by repeated painting and scraping.

The palette knife can also help to control the paint surface of the canvas. With it you can scrape areas that become too thick for anticipated changes or are desired for the textural progressions being worked out. An important part of the flexibility of painting is the fact that paint can be scraped off. Too many students become prisoners of their previous acts. Change your mind freely; scrape off paint when it gets in your way.

The palette itself can be any relatively non-absorbent surface whether of wood, paper, cardboard, plastic, glass, and so on. In your own studio it might be a table top, or a piece of glass either by itself or with white or gray paper underneath. Commercial boxes contain wooden palettes or metal ones that suit the classroom or outdoor painting situation.

The palette knife will help you control the surface of the palette. Keep the mixing area clean; do not allow it to become so confused with paint that you cannot mix a desired color. Knife up the used paint into grays that will later prove useful.

Since I like the prismatic gray of dried paint to mix against, I allow a gradual accumulation of flat residue on the palette. For egg tempera I use a glass palette with white paper underneath, primarily because I tend to use it

semi-transparently and wish to mix the tones against white. This could also be the case in painting with oils or plastics whenever the white of the canvas is to become a factor in the color, or whenever transparencies are employed in large measure. In such a case the palette needs to be cleaned throughly.

Since paint can be used from week to week, one should not scrape off the unused portions. Commercial boxes are built so that the palette will be held in a position which allows the paint to be undisturbed.

In addition to brushes, palette, and palette knife, you need containers to hold the turpentine and medium. These containers, called cups, are designed to be fastened to your palette. In your own studio you may find that a coffee can with a top and a screen inside will be more satisfactory. I find that putting the medium also into such a container helps to control its chemical changes and so allows me to use it more than once.

Finally in the list of essential materials, rags and old newspapers are indispensable. It can be said that an artist holds a brush in one hand and a rag in the other.

Drawing Materials

A painter draws and paints simultaneously. But there are times when he simply draws. The important thing about drawing materials is that they should remain quite simple.

Charcoal is the usual means, but needs fixing; if you are not going to protect your drawing with fixatif, use conté crayon, ebony pencil, or lithographer's crayon instead of charcoal.

The means of drawing selected will determine the paper used. For charcoal, use charcoal paper; it needs some texture and tooth to bring out its rich qualities. The crayons, on the other hand, can be used on varying surfaces such as bond paper or drawing papers available in various plies of thickness. The more detailed your work is to be, the smoother the paper needs to be. A medium surface is perhaps your most flexible choice. Paper becomes permanent to the extent that it approaches 100 per cent rag in content.

Newsprint pads are useful in quick sketching, though they tend to become brittle and change in color rapidly. You will need a variety of drawing pads, one small enough to carry around, a large pad for quick sketching from the model whether in your studio or in the classroom, and a medium-sized pad for pen-and-ink drawing.

When ink is used, it should be a rich black as in India ink unless sepia or other color is desired. Your pen can be almost anything from one with an ordinary point to those with flexible drawing penpoints. Drawing fountain pens are sometimes very good, but you should test their flexibility before purchasing. Black ball-points are often useful, but their value range and line are too easily fuzzy. The smoothness of the paper should be sympathetic to the pen used.

For drawing with brush and ink, I suggest a medium-sized red sable round-hair brush. Do not shy away from pen-and-ink drawing. Handle or brush it boldly.

Drawing and painting are intertwined when drawing mediums involving color are used, such as colored inks, pencils, crayons, pastel, or such combinations as wax and pastel, or oil and pastel. Such combinations are extremely useful in special situations, particularly when you can carry little equipment and wish to make color notations as well as notations of dark and light. The combination mediums allow a full-bodied development without the problem of drying or rubbing off.

Pastel painting requires a special toothed paper. Pastel papers vary from those that are similar to charcoal papers but heavier, to those with velvet and sandpaper surfaces. Medium light gray tones are recommended. Avoid fixing pastel paintings, since none of the fixatifs work completely. The paintings must be kept in portfolios or framed under glass with a heavy mat.

A large, strong, flexible easel will also eventually be needed for your studio. You will need the kind that adjusts with a crank, tilts as desired, and takes a variety of sizes of canvas. Until you get such an easel, get any cheap kind because nearly all will be inadequate. If you have a wall to which you can tack a canvas, you can paint without an easel.

Unless you need to sit for physical reasons, you should arrange your painting situation so that you can paint standing up and have room to walk away from the painting. Classrooms often do not allow such freedom; in that case, you may have to put your canvas away from you frequently so as to see it better as a whole.

While most artists seek and demand relatively large studios, there are some who through preference are quite satisfied with circumscribed situations. Much depends on the artist's approach to his work. Painters who work by means of adding part to part (see Chapter V) can more easily function close to their work. Those who progressively modify the whole of the painting need far more room and flexibility.

In all these choices of material means, use those that interest you. Do not think of mastering one means before another. In both painting and drawing development should be continuous; both are life-time propositions.

If no particular medium interests you, use the one that suits your situation. As you experiment you will acquire more and more information about materials and technique. When you feel the need for more theory, read some of the good available books on materials.

In this way you will continuously be discovering new ideas, relationships, and skills. You will be surprised to see that technique will prove to be the least of your problems, particularly as you learn the values of patience. But technique and materials cannot be separated from expression, if that expression is to be organically whole. It is to such problems that we will now turn our attention.

CHAPTER V
COUNTERAPPROACHES

Modes of Work

There are, as we have suggested, two main modes of approaching the elaboration of a problem. One might be called the addition method, the other the "whole" method. The addition method consists of adding one part to another, each determined by what is already there. The "whole" method begins with a general statement that fills the canvas or page and becomes progressively modified. The former method, as we shall see, stresses line as edge and consequently stresses shape relationships. The latter is more fluid and spatial, using line more as direction or movement than as edge; it is more three-dimensional in feeling than the addition method.

The Addition Approach

The addition method of approaching painting involves on the part of the artist a heightened consciousness as one part of the painting is added to another with sensitivity and strong personal involvement. From the inception of the work, this method is characterized by attention to detail. The whole is an accumulation of details, each designed as a part and related to the totality of the work. The work itself tends to be less fluid and more closed than otherwise, with a clearer, relatively flatter pattern of dark and light and color. The work easily becomes decorative.

Theoretically, a mistake is impossible with this method, since whatever is added to the work can be psychologically and plastically compensated for

PLATE 13

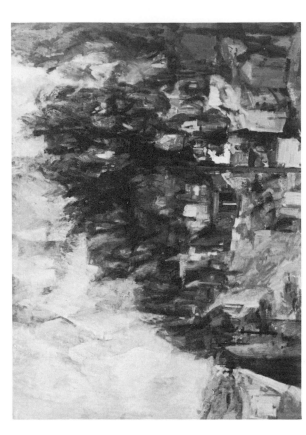

BEDFORD HILLS
The "whole" method begins with a general statement that fills the canvas and becomes progressively modified; it is more fluid, spatial.

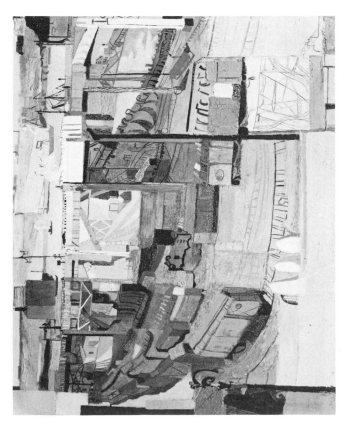

Collection of George Schiller. Photograph by Osti

RAILROAD YARD
The addition method consists of adding one part to another; it stresses line as edge and consequently shape relationships.

PLATE 14

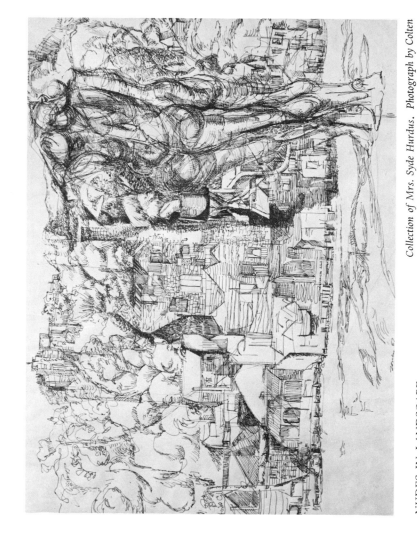

NUDES IN LANDSCAPE

The addition method generally begins with a line drawing.

Collection of Mrs. Syde Hurdus. Photograph by Colten

Begin where you please but draw at once boldly and sensitively.

until the relationships seem right to the artist. Chance happenings are automatically absorbed into the work.

As a tradition, this method has persisted from the naturalistic contour (outline) drawings of prehistoric times (see following section), through the Egyptian, Byzantine, and Gothic periods to the present. It is congenial to the closed form of classicism but adaptable to the needs of such romantics as Modigliani or Van Gogh. The method is one used equally by sophisticated painters and by the naïve. Most beginners, as we shall see, draw in a contour or addition fashion; whereas blocking in or constructing a drawing as in so-called gesture drawing, has to be learned.

Whether one is drawing or painting directly from visual material or from symbolic or other ideas, this method generally begins with a line drawing. This is not necessary, however, since the artist may create shapes directly as masses or silhouettes. The actual drawing may proceed with a slow deliberateness and a sensitive awareness of every nuance of contrast and similarity, or it may proceed rapidly and freely.

The line used in this method can vary greatly within the work or can be relatively consistent. It may be thin, wiry, and continuous, or may be made of short strokes which are thick or heavy and calligraphic. Line here can simply mark the edge of shapes or it can imply the illusion of three dimensions. It can work as line counterpointing mass or simply as line alone.

Contour Drawing and Painting

In contour drawing or painting, the artist, working from the model or physical visual resource, fixes his attention on the edge of the surface with which he is dealing and acts as though his lines were actually touching that edge. This psychological identification tends to add sensitivity, variety, and depth of perception to the line.

Various contour exercises have been practiced by artists as ways to develop varied skills and search out possible visual ideas. One is that of direct drawing with a sensitive, consistent line, keeping to the edge and sensing spatial as well as shape relationships,* gradually filling the page in an exciting and harmonious way.

Another exercise is that of not looking at the paper but fixing one's eyes on the model and drawing as though one were tracing the edge, until again all has been put down that interests the artist. In this case, of course, the result incorporates far more accident than in the first exercise.

The contour method generally develops sensitivity to detail, pressure, and shape, and clarifies one's understanding of the plastic role of shape and line and the possibilities of pattern. Moreover, it illustrates the role of accident in the creative process. Fixing one's eyes on the part rather than the whole tends to distort the relationship of that part to others; inevitably the distortions accumulate and the drawing becomes a synthesis of error in judgment and coordination as well as of sensitive observation.

*See Chapter VII, pp. 131–153, for a fuller discussion of line, and shape and space relationships.

PLATE 15

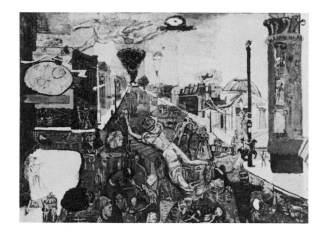

FOUR CORNERS
The addition method is characterized by attention to detail.

*Contour drawing: fix your eyes on the model
and draw as though tracing along the edge.*

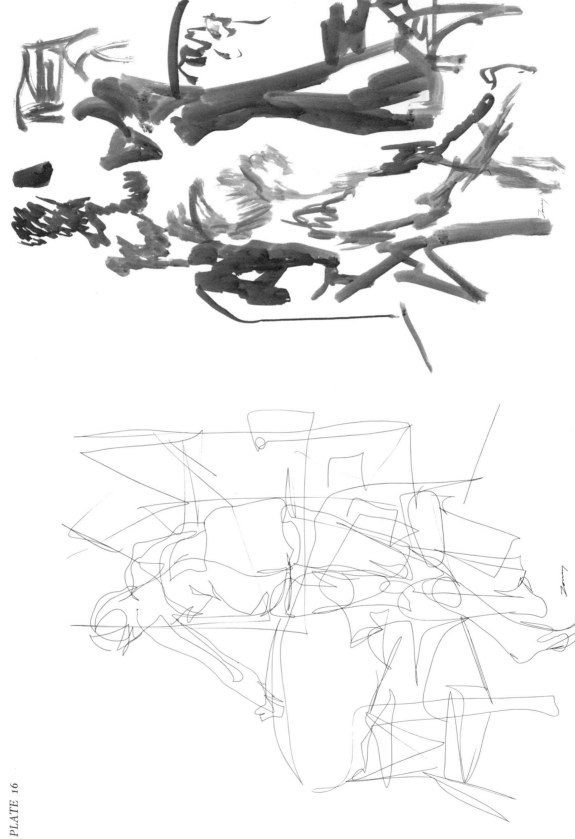

PLATE 16

The artist may create shapes directly as masses or silhouettes. The line may be consistent or vary; it may be thin, wiry, continuous, made of short strokes, or thick, heavy and calligraphic.

Use the continuous line more freely. Draw as though roaming over the surface, allowing caprice and consciousness of contrast and repetition to suggest direction and relative complexity.

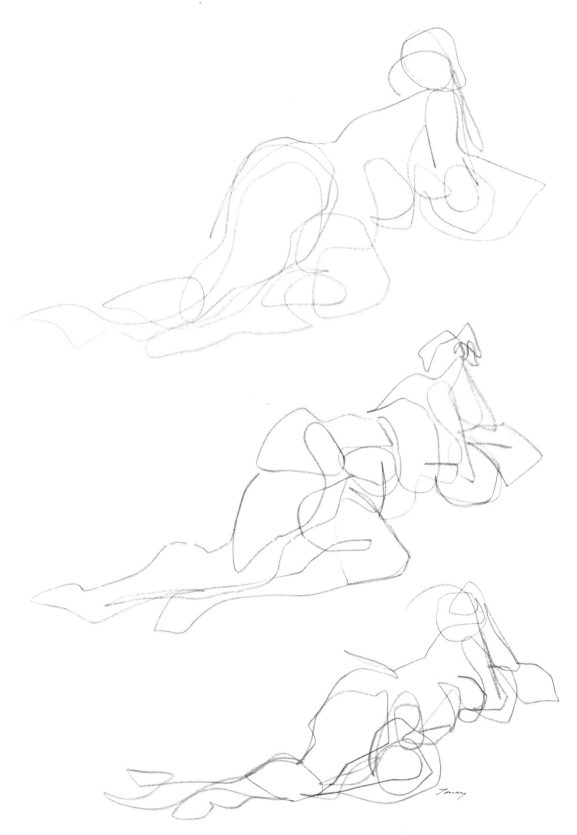

PLATE 17
Repeat drawings of the same pose. Compare them for the different plastic ideas suggested.

PLATE 18

CREMATORIUM

Stress on line sharpens value pattern and shape relationships.

Contour study of figure.

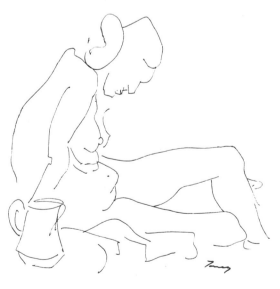

PLATE 19

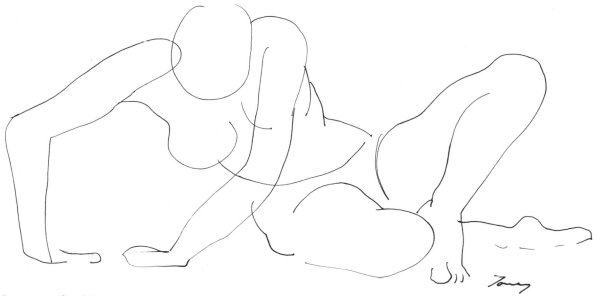

Contour study of figure.

Contour doodle. Most doodles are
contour in character.

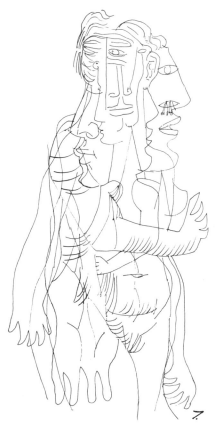

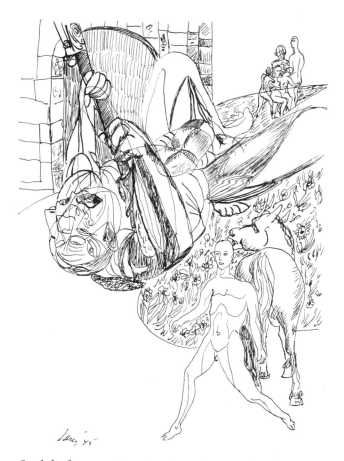

Symbolic free-association drawing. Contour drawing
need not be done from nature. Add one line to another
as lines suggest themselves.

C

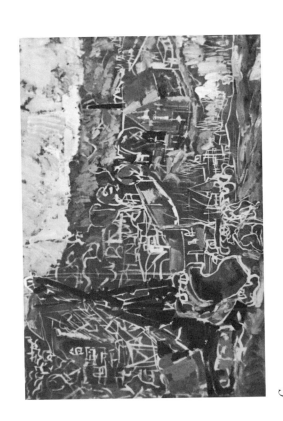

A. The addition method can begin as a line drawing as here, a white line on sienna ground.

B. The painting proceeds by progressive statements of plane relationships, one plane added to another.

D. Each plane is established directly and as if finally.

PLATES 20 AND 21
PANORAMA WITH STEAM SHOVEL

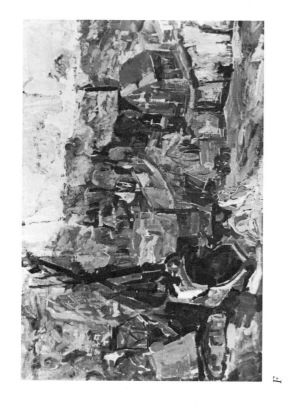

F

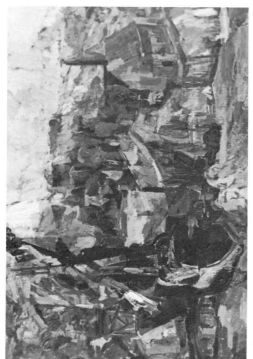

E

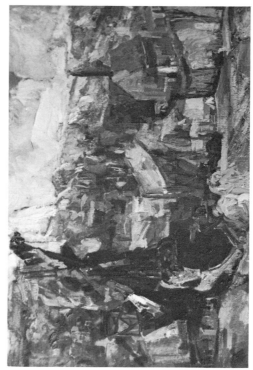

G

H. Only as the whole becomes stated can it be evaluated.

Collection of Mr. and Mrs. Alex Rittmaster

Similar exercises use the continuous line more freely. Draw, for instance, as though roaming over the surface of the model, allowing caprice and consciousness of contrast and repetition to suggest both direction and relative complexity.

In addition, experiment with wide brushes, sometimes so wide that the stroke suggests the complete silhouette. Fill the page with varied shapes of contrasting value (i.e., relative lightness and darkness). Establish the figure as a heavy calligraphic gesture. Use a variety of means including that of paint.

As you add line or shape in value or color, keep these elements relatively large but contrasting in size and relationship. Be conscious of their space-plane relationships: which is behind or in front of what other shape? Does a shape seem to come forward or go back? In all these exercises, continue till you fill the page; only then can you tell whether yours is a resolved composition.

Contour drawing need not always be done from nature; it can be done equally well if the subject matter is imagined. One simply adds line or shape as they suggest themselves. This method may result in naturalistic, symbolic or abstract images.

Particularly in the explorative stage of painting or drawing the emphasis upon line and flat areas will help in the discovery of pattern, for the limited character of the method allows the artist more trials. This method is even easier if transparent paper is used and ideas are overlaid until the desired pattern is found.

While there is a relative flatness to this way of proceeding, it often incorporates some illusionistic space with modeling that may be shallow or very strong. In either case the shapes maintain their identity as shapes however much they may be complicated by movement of planes within. If the modeling is strong, the light and dark areas may work as separate shapes.

Many classicists have used this kind of contrast to achieve a duality of illusion and relative flatness, as in contradicting modeled underpainting with uncomplicated transparent local color (i.e., the actual color of an object). This propensity for space opposition, for ambiguity or ambivalence, helps at once to maintain and destroy space illusion and thus keep our awareness of the flatness of the canvas or paper.

These relationships are a form of cross-fertilization of ideas, about which much remains to be said. Here it can be noted that the distortions result in relationships that are highly interesting and usually more exciting plastically than more accurate copying would be. The accidents add contrast—more definite changes in shape and size—and they are psychologically suggestive, yielding more readily to personal associations.

Thus exercises in contour drawing become useful in the early stages of the creative process as one searches for transformations or symbolic shapes. In the process the artist's attention to sensitivity to line and shape is extended to each of the elements, each detail lovingly attended. This precision, however, does not negate spontaneity but rather aids it in its development.

PLATE 22

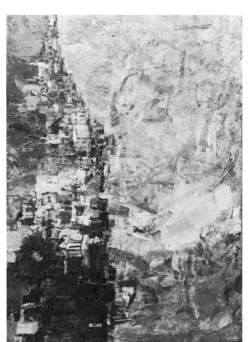

STATEN ISLAND NEAR ST. GEORGE

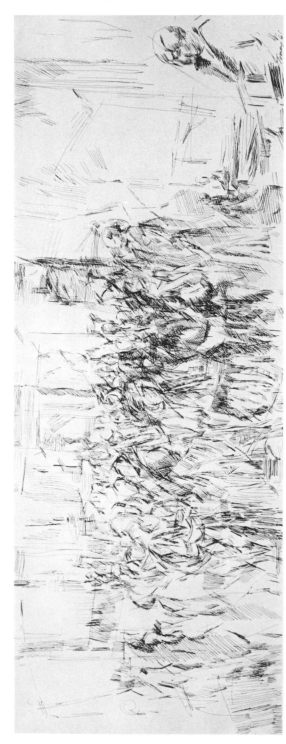

THE GALLERY (Drawing)
The whole method remains open until realized. It proceeds through a series of stages,
from mass to detail, simplicity to complexity and back again.

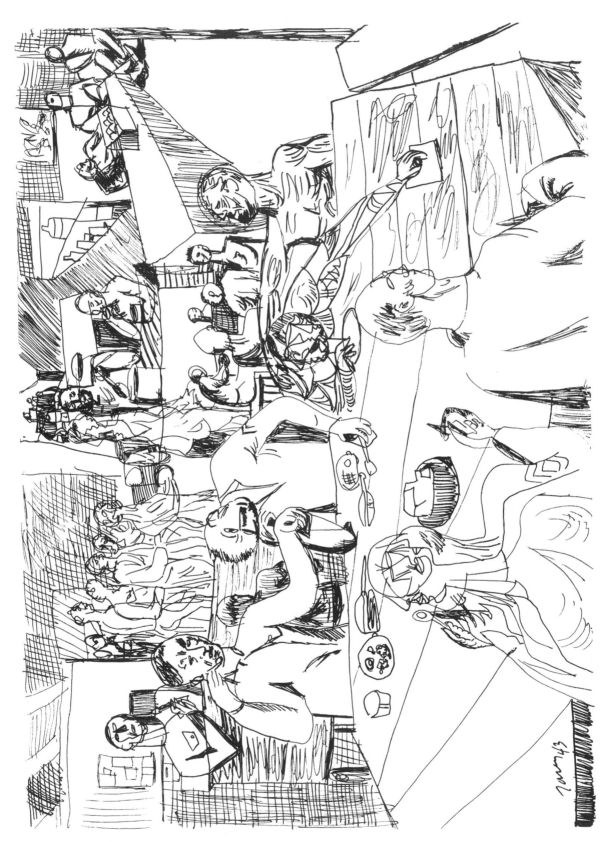

PLATE 23. MESS
Free-association war experiences.

The Approach to the Work as a Whole

In contrast to the part-by-part method of building a work of art is a second method that begins with a rough whole. Here, first the limits, the principal thrusts, the general visual contrasts, are broadly stated; then these are progressively modified until the work is completed. The work proceeds through a series of stages, each somewhat complete, moving from the general to the particular, from mass to detail, from simplicity to complexity and back again. It remains open until realized. The stress on movement creates fluidity, enveloping space, and the feeling of atmosphere. This method is far more flexible than the part-by-part approach and allows the accomplishment of any goal.

Gesture Drawing

In gesture drawing as opposed to contour drawing it is the place, direction, and relative mass or general implied shape of relationships that concern us, not one particular contour. Many students think they are making a gesture drawing when they imitate its feeling for space and movement, but since they are merely adding one part to another and are specifically concerned with parts, their drawings are only another form of contour. Gesture drawing depends upon working from the whole rather than from the part.

Both gesture drawing and painting have an analytical base. Geometry— the primary oppositions of the visual elements—becomes the main means of seizing the essential relationships of the complex phenomena drawn or painted. Whatever is drawn, therefore, is established first in its largest geometric aspects, which are freely moved until they are right. Each complexity is sensed in terms of the oppositions it contains. Directions, masses, and shapes are contrasted not only with one another as they are, but with simpler geometric oppositions that reveal existing deviations.

Positions are checked relative to one another, through the use of horizontal and vertical lines or by simply seeing what lines up with the direction being drawn. Linear continuities include similarities of positions and direction as well.

As in contour drawing, a psychological identification between artist and painting is desirable; it is obtained by drawing as though one were caressing the surface of the form itself. In figure drawing the lines move over the anatomical or fold structure as revealed by light and dark. The line moves sensitively with the form, following the dark or light indications.

The relationships thus discovered may be explicit or implicit. Explicit shapes are the actual shapes of an object. Implicit shapes, on the other hand, are hidden. The implicit shape is the overriding or general shape—perceived continuities that connect separate things.

The analytical process of gesture drawing provides a means of breaking the complexity of anything into its parts and thereby understanding and

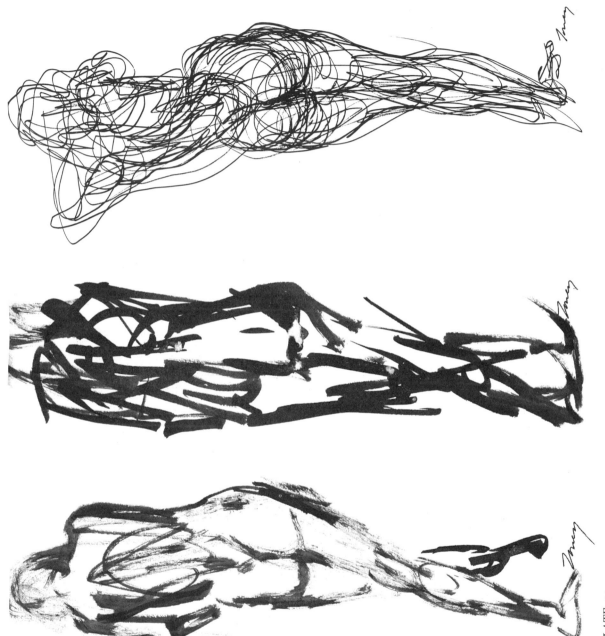

PLATE 24
Variations of gesture figure sketching

PLATE 25

*Gesture drawing has an analytical base. Establish large geometric shapes first:
triangular, rectangular, and circular. Primary movements: vertical, horizontal,
curvilinear. Align parts with each other and with environment.*

PLATE 26
In gesture drawing move at once from top to bottom. Grasp the largest movements, the swing of the whole. Draw from the inside out. Draw as though you were touching the form.

PLATE 27

In gesture drawing take your cues from the anatomical structure. Feel the movement of body parts relative to each other. Keep your line fluid and sensitive.

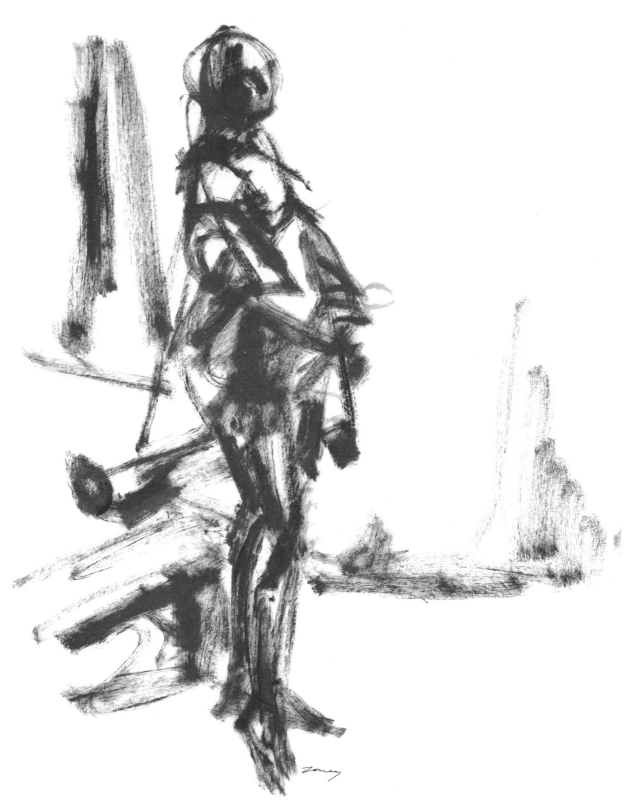

PLATE 28
Gesture drawing is calligraphic. It can be done boldly with large brush strokes as well as tenderly.

controlling them both as parts and as a whole. It makes possible an accurate copy or any kind of transformation. The gestural method is constructive and completely flexible.

In gesture drawing keep your lines light until you are certain of proportions and directions. You can control the value of your line through the pressure on the paper. Keep the pressure light in light areas and stronger in the dark areas, but approach final darks gradually, working the drawing as a whole. Move from the inside of the work out. Your contour should be established last. Depending upon your goal, the line of the contour will need to be sensitive, but will be briefly lost and found again, sharp and fuzzy, as the edge turns against similar or contrasting surfaces.

Gestural Painting

As with gesture drawing, gesture painting is calligraphic. The drawing and painting acts are simultaneous. It is bold, fluid, open, following the suggestions previously given: first the largest masses, the main contrasts, then the thrust and counterthrust of ideas until the whole is transformed into the desired coherent totality. Its expression is best represented by the baroque of Rubens or by Rembrandt, or in the realism of Chardin or Vermeer, though it is equally evident in the naturalism of Degas, the impressionism of Pissarro and Monet, and the work of our contemporary abstract impressionists.

The "whole" approach to painting is particularly sympathetic to the needs of so-called action painting. Since sketches and studies are dispensed with or are used only as points of departure, the openness of the method allows the painter to expose the entire creative process on the canvas.

The essence of gesture painting, then, is its wholeness from the beginning, used as a beginning and changed until the tensions arrive at the desired equilibrium. Unfortunately, too many students become imprisoned by what is first put on the canvas. You must work spontaneously and automatically, freely changing anything, adjusting, reacting, and adjusting again. From the outset establish directions and masses that extend the entire length and breadth of the canvas. These, however, represent only first estimates. Boldly superimpose other ideas again and again. Many students in working on a canvas are preoccupied with the positive areas (the figure alone) and do not know what to do with the other areas (the background). The method of gesture painting precludes any such preoccupation. Your negative areas, or those between objects of main ideas, are as important to your design as the positive areas and must be stated with similar attention.

Students are always asking what they should paint. Unless you have another idea, paint what is in front of you. Cover all the area. Try to think less of what is represented than of place, position, length, breadth, direction, dark and light, color, and space and textural contrasts. Ask yourself, is this area or that larger or smaller, in front of or behind, darker or lighter? Is a color better here or there, extended or contracted, more intense or less?

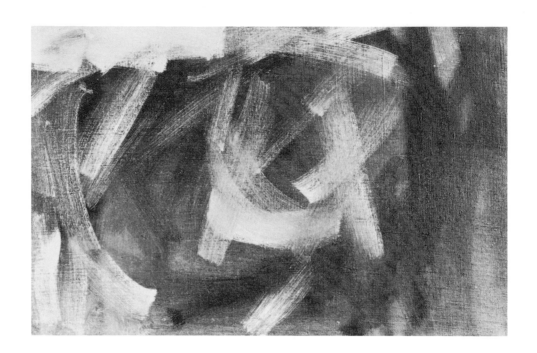

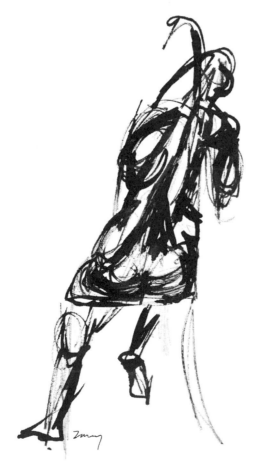

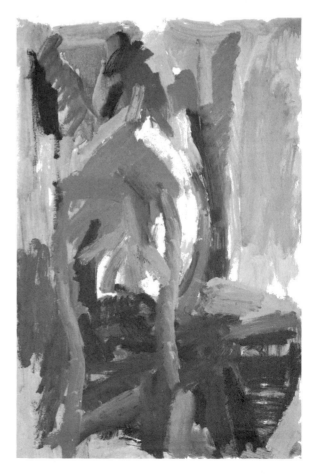

PLATE 29
In gesture painting the drawing and painting acts are simultaneous.

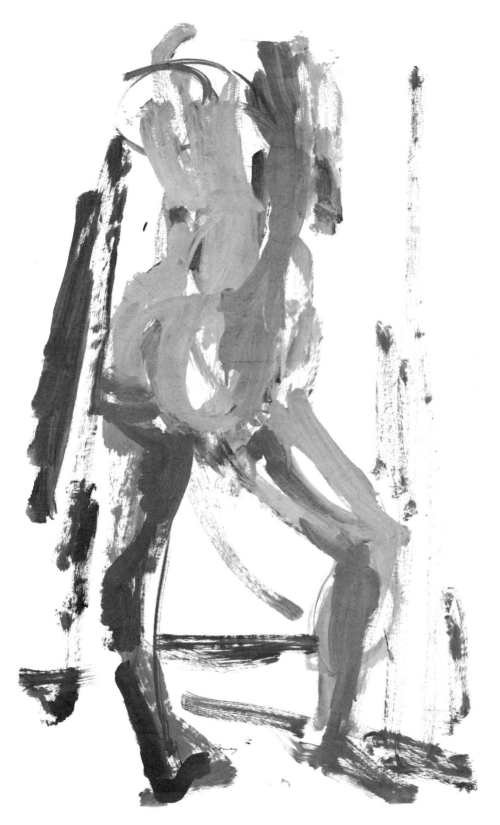

PLATE 30
From the beginning establish directions and masses extending the whole length and breadth of the canvas.

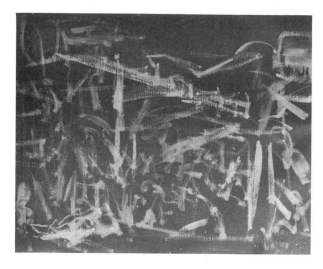

A. The beginning: broad bold sweeps of contrasting movement of white on sepia ground.

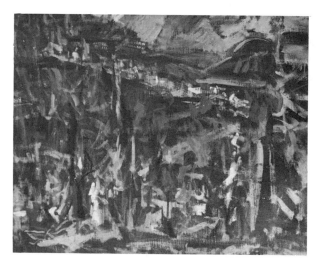

B. Panoramic relationships established in broad calligraphy of color and value.

C. Ideas elaborated upon; patterns searched for.

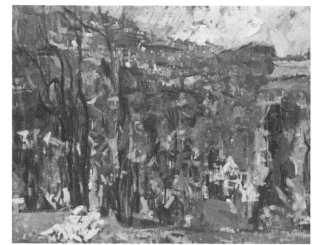

D. *Thematic sequences explored further.*

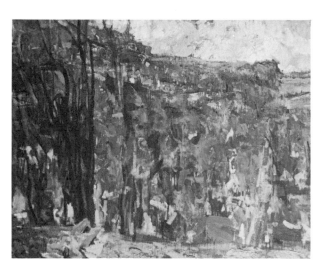

E. *Vertical and horizontal movements stressed. Weight established in middle ground trees at left, psychologically intensified by reclining figure at left foreground.*

F. *Weight or force relationships further clarified. Circular counter ideas strengthened.*

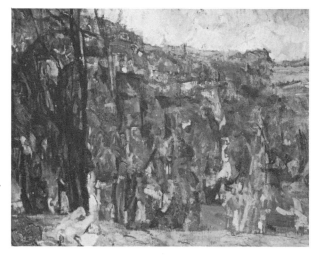

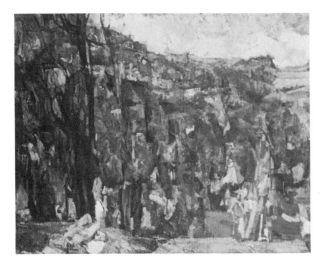

G. *Final decisions.*

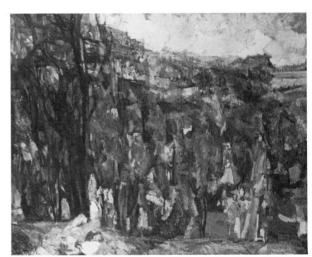

H. *Resolution.*

Collection of Nellie Rand

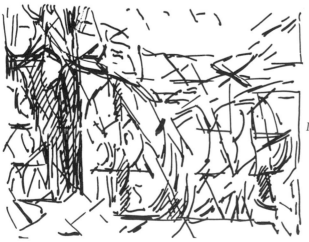

I. *Diagram of main shapes and movements. Main theme is counterpoint of circular and vertical movements, main shape idea rectangular; circular shapes are subordinate. Actual and implicit triangles form counter shape idea. Climax is in lower left area. Web of implicit spokelike patterns underlies overt structure.*

Even if your goal is not naturalistic, if you are working from nature compare nature to your painting in terms of the visual contrasts embodied. Doing this will help you to see their relationships. What seems very dark becomes lighter if seen against something still darker; similar analogies will reveal actual color or value. Comparison of similar qualities, and of complex factors with simpler ones within the whole context, help you to see where they belong.

Search for the order in nature; it will be revealed by visual contrasts. Gesture painting and drawing are the most flexible means of searching out inner connections and interconnections of structure. Do not shy away, therefore, from the study of anatomy or perspective. All that you learn will make your ideas richer, even if finally you choose to paint abstractly.

The thrusts and counterthrusts need not start from nature but can stem solely from the contrasts happening accidentally or spontaneously on the canvas. If you choose to work this way, stay with it. Do not become enamored with early beginnings; give yourself more choices. The painting will become richer the more you work with it. The first part of the creative process takes time. Be patient. If your painting starts to get away from you, pause and put it away. As your ideas become clearer, prepare your surface by cutting out superfluous paint so that your new ideas can be stated with clarity and boldness.

In art boldness is decisive. From the beginning paint with conviction, at once sensitively and with authority. Just as boldly, change your mind. Do not allow yourself to be timid or afraid of your materials or mistakes. State the contrasts and try again and again until the painting looks good to you. If it does not, it may still be good; but even if it is not, there will be another time. You have gained important experience. It will all count toward helping you to see and control your materials.

Interaction of the Two Modes of Painting

It does not take the painter long to realize that the two modes of painting we have described—that of the whole versus the part, gesture versus contour, movement versus shape—are actually inseparable. Sooner or later the gesture becomes some sort of shape and contour is arrived at; similarly, the shape moves in space and becomes a whole. As the part-by-part approach is completed, it can turn into an emphasis upon movement; similarly, the gestural approach, in becoming involved with shape, pattern, and linear qualities, can turn into an emphasis upon these. Thus a Poussin, for all his closed classical form and architectural structure, creates a synthesis with the openness of baroque; his edges begin to melt and the part is swallowed in the larger whole.

It is further true that a contour is not simply an edge; it is also a surface, one that actually is anywhere. As such it is similar to the line of gesture, which may also roam the surface.

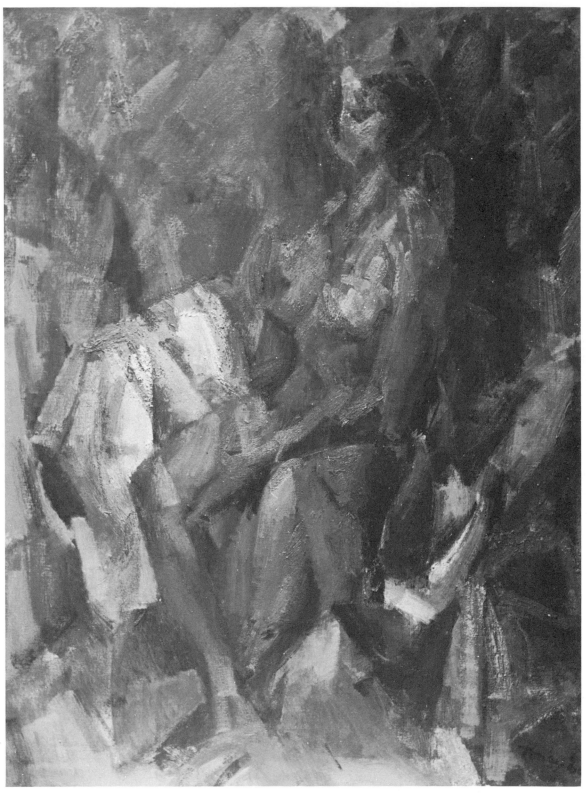

PLATE 34. *PURPLE NUDE*
Thrusts and counterthrusts can develop into a copy of nature or any kind of transformation.

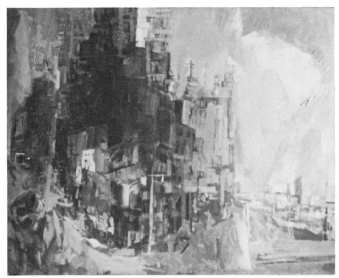

LOOKING NORTH FROM SOUTH FERRY

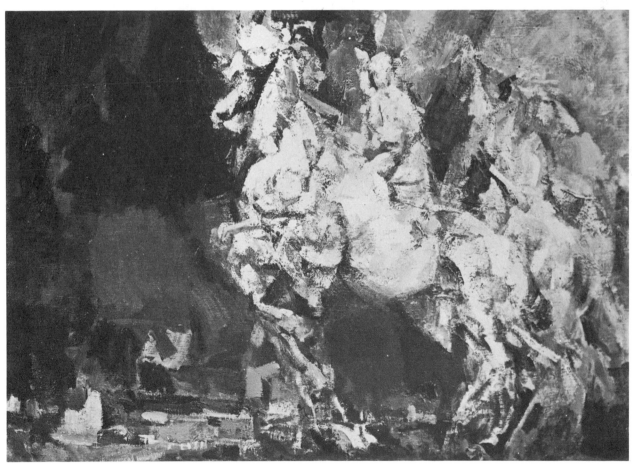

PLATE 35. HORSES AT NIGHT
*Derive and stress plastic relationships from meanings in your work. Description and
personal identification must become transformed into organic visual whole.*

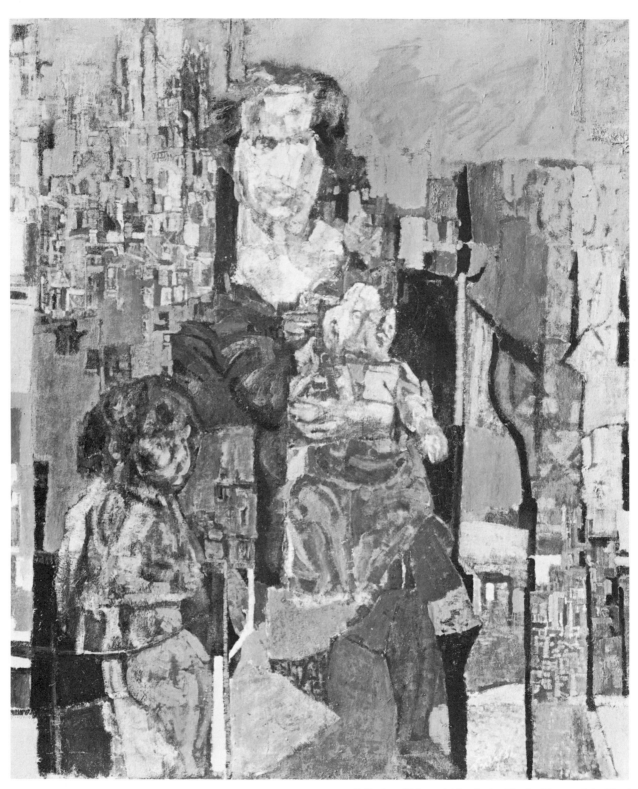

PLATE 36. MOTHER AND CHILDREN
As gesture approach becomes more involved with precise shape, pattern, and linear
qualities, it can turn into an emphasis upon them.

The distinction lies, therefore, not in such exact qualities but in how the painting is made. Contour is more precise from the beginning, gesture more general. The crux is the part-by-part method compared to that of the whole.

Both, however, demand for sensitivity and meaning a psychological involvement of artist and work of art. Both demand the duality that couples personal identification with a consciousness of the interplay of visual contrasts and forces.

The problem, and the greatest contradiction, is to feel the description or meaning without being essentially descriptive, and it is not an easy problem to solve. I attempt to solve it at times by placing stress on the plastic, feeling that the identification will remain. Stress upon one or another quality (psychological or plastic), therefore, may be necessary in particular drawing or painting situations. Both, however, actually play simultaneous roles.

Direct and Indirect Painting

Direct and indirect painting are two technical approaches to painting that oppose and interact with each other. Direct painting refers to the process of mixing the desired color, value, and texture and putting it on the canvas where wanted. If the process is right, it becomes the actual painting; if it is wrong, one must mix another quality of paint and put it as forthrightly in its place. Each time, one should attempt to mix the quality desired and put it on as it is to function, stating each modification with equal directness.

In essence, if it were possible to establish the whole canvas with one stroke, direct painting would do so. It is calligraphic, at once descriptive and plastic. Sargent and Sloan were direct painters, and up to this point we have been largely discussing direct painting.

Indirect painting, on the other hand, is any type of painting where the intent is to accumulate interacting layers of surfaces that modify one another so that the painting is not completed until the last touch. No surface, color, or value is right by itself or put on as though it were the finished product; rather, each is established with the idea that another will go over it and modify it in some way. The various forms of transparency involved in indirect painting include dry brush, glazing, scumbling, various uses of the palette knife, and other techniques that will allow previous layers to play positive roles in determining final qualities.

One form of indirectness is the underpainting, scumbling, glazing approach. According to this method the main drawing, value, shape, space, or even textural contrasts are stated in neutral tones, usually earth colors. This underpainting may be carried into greater or lesser detail, but its whites and darks will in either case be somewhat intensified. After the whole is allowed to dry, the color is scumbled upon the dry surface (i.e., transparent color is put on and wiped off as general color ideas are sought). Wiping off the first layers of transparency prevents too early richness of medium and greater flexibility of color research, since the cross-fertilizations of color suggestions often

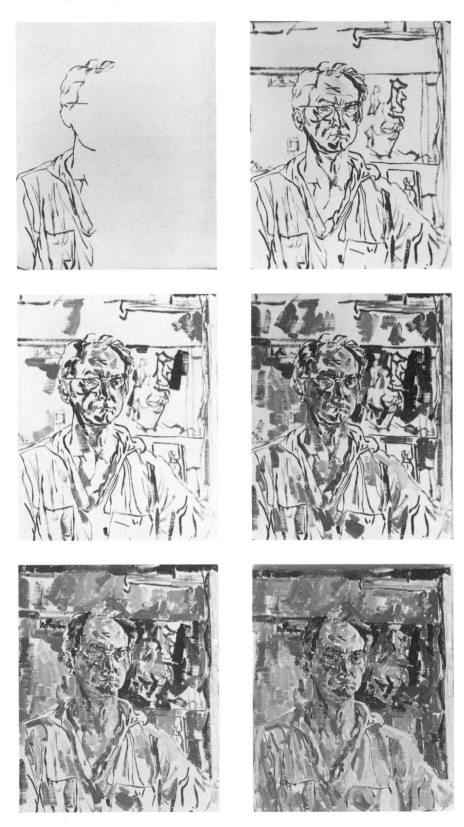

Direct painting by addition method. Series starts with contour drawing, with plane after plane added.

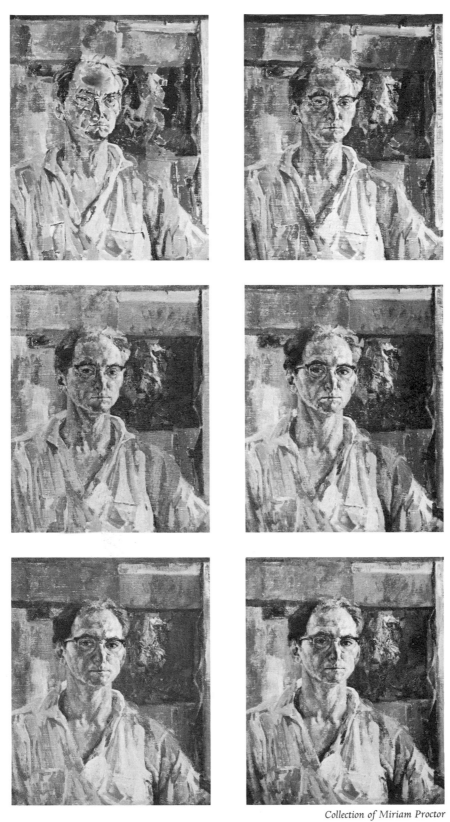

Modifications may be necessary once a whole is reached because of thematic sequences and other structural relationships.

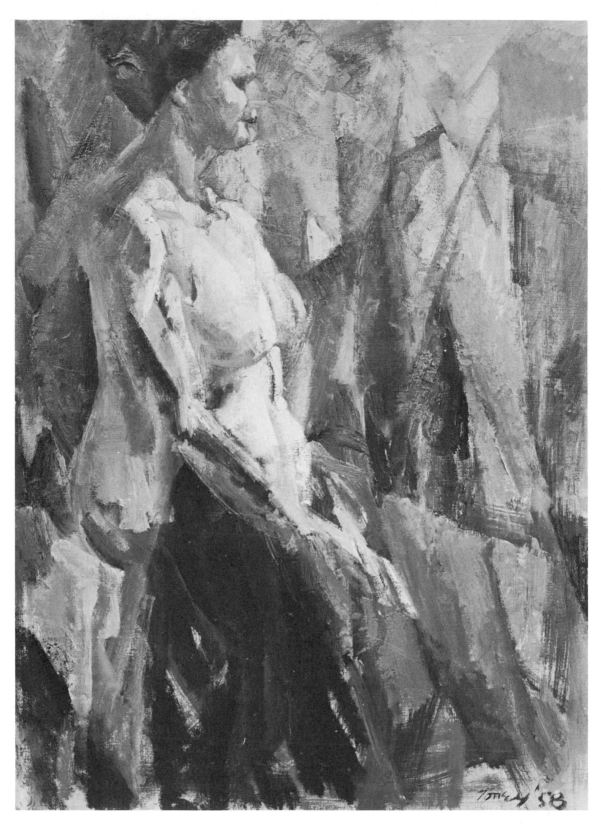

PLATE 39. SEMI-NUDE
Direct painting is calligraphic, at once descriptive and plastic.

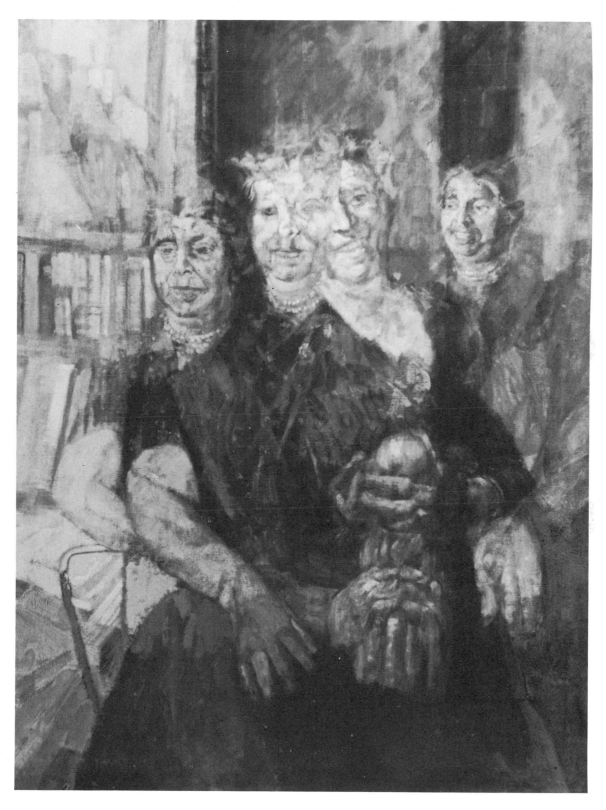

PLATE 40. SUSAN

Indirect painting accumulates interacting layers of surfaces, with various forms of transparency as well as opacity employed.

yield exciting color ideas. Finally, the color ideas are further intensified by the application of small and larger glazes (transparent tones that are not wiped off but are usually controlled through gentle blotting and careful concern for the amount of medium).

The technique of underpainting was developed to give artists greater flexibility in their search for more adequate naturalistic means of expression. It characterized some late Gothic and most Renaissance painting.

The method as traditionally used proceeds systematically through several stages. First the canvas is generally toned with umber or sienna. When it is dry, a drawing is superimposed. This is further developed by painting the light areas with a quick-drying white. Variations of value are stated by variations of pressure, using a dry-brush technique that permits the value to become darker as pressure is released. The lightest lights are therefore invariably thicker than other parts of the canvas. The canvas tone serves as middle tone and the darker darks are reinforced. Some white is then gently superimposed in dry-brush fashion over the whole. The white underneath increases the luminosity of the color.

When this underpainting stage is dry, scumbles and glazes are added as already indicated. Thus the value and color problems are separated. The color tends to be more local, although the best painters always were aware of differences in warmth and took advantage of them both within the local color and the counterpoint of color.

This underpainting technique is rarely used in any absolutely consistent form and may be modified in various ways. Some direct painting is generally employed, but not so that such areas are isolated, rather so that they fit in with the whole. When serious changes are desired, these are painted with white over the previous glazes and the procedure is continued.

The underpainting in white can also be begun in general or larger areas and allowed to dry. Then color is scumbled or glazed over the whole. Over the dried surface elaborations or changes are superimposed with white, each time sensitively over the whole canvas. After that layer is dry, further color elaborations are scumbled and glazed upon the surface and allowed to dry. Further changes are painted in white as before and, when dry, color applied transparently, a procedure which is repeated until the precise drawing and color qualities are achieved. Areas of the underpainting occasionally serve as finished areas without alteration. Some Goyas have such sections that are unchanged.

While the above technique is usually the culmination of the creative process—a rendering of ideas thoroughly explored in sketches and drawings—in the more flexible form stated it can be more open.

Modern painters have considerably varied the underpainting or indirect approach, mainly through some form of synthesis of kinds of transparency. In the same painting, areas will have the transparency of dry brush, glazes, blotting, palette-knife scraping, and so on. So long as these are orchestrated throughout the work there is no problem.

A

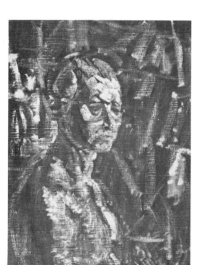

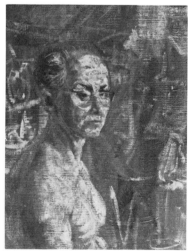

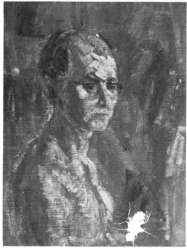

B. Drawing established broadly in
gesture fashion with white on
sienna ground.

C. Whites used in dry-brush fashion, firmly and thickly
where lights are desired, more tenderly and lightly
where darker values are suggested. Extremes of
white and dark exaggerated because glazes darken
lights and lighten darks. Some white over entire
canvas to maintain consistent quality.

D. Color scumbled and glazed over
dry underpainting.

E

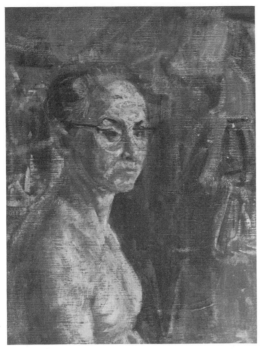

F. *Drawing modified with white again.*
 When dry, further glazes applied.

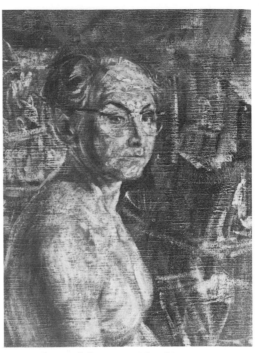

G. *Further modifications with white.*

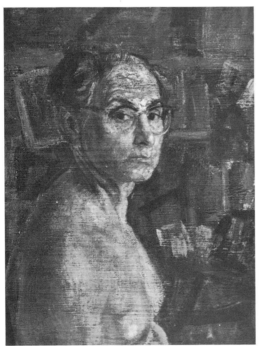

H. *Alterations with white toward further*
 elaboration and subtlety of relationship.

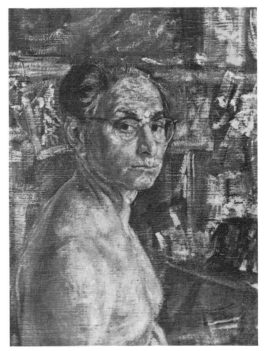

I. *More elaborations of transparent color.*
 Search for formal ideas.

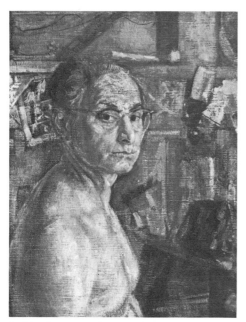

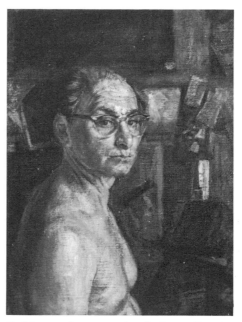

J. *Further strengthening of main rhythms. Final adjustments begun.*

K. *More and more precise glazing and redrawing, sometimes with opacities.*

Collection of Syracuse University

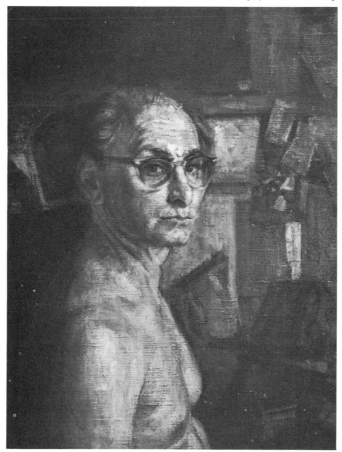

L. *Final resolution of self-portrait in underpainting technique.*

PLATE 43

KATONAH AVENUE

Collection of Mr. and Mrs. George Schiller

STATEN ISLAND PANORAMA

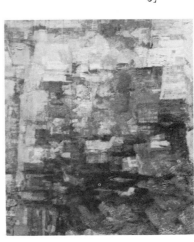

Collection of Dr. and Mrs. Arthur Kahn

Modern painters have varied the indirect approach considerably, using various forms of transparency and opacity even on the same painting.

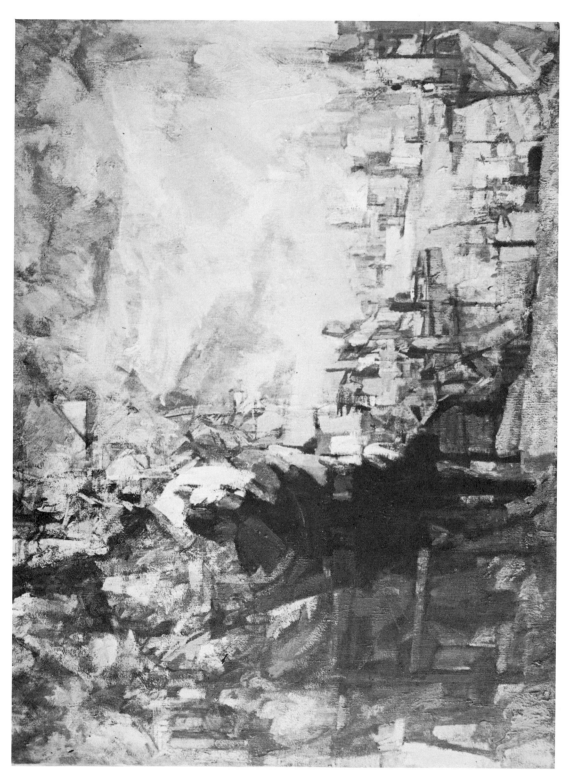

PLATE 44. CONVERSATION

Experiment with wide range of possibilities. Certain kinds of subjects or situations demand particular technical solutions. Harsh contrasts can be neutralized by a glaze over the whole work and then changed further as necessary.

Sometimes harsh contrasts are neutralized by a glaze over the whole work and then changed as necessary.

By simply putting on paint and cutting it off with the palette knife the painter can achieve a rich variation of tone and color. The dripping or pouring of transparent layer upon layer of paint is another form of indirect painting.

You will need to experiment with the range of possibilities open to you in regard to direct and indirect painting. Certain kinds of subjects or situations will demand particular kinds of technical solutions. Discovering these is part of the early stage of the creative process. Certainly direct painting may be best for certain kinds of sketching and for some kinds of naturalism. Since impressionism, however, naturalism has required some measure of analytical color, and this is sometimes most easily achieved by some indirect means such as dry brush and glazing.

CHAPTER VI
OUR MODERN INHERITANCE

In every age a matrix of social forces has conditioned the artist's mind, dictating the expression and aesthetics of his day. Today, our highly competitive, anxiety-ridden culture has created its own particular forms of expression. Science, as revealed in technology, has immeasurably extended the artist's frame of reference. Micro and macro photography, the film medium, contrasting communication experiences, the splitting open of nature's structures, the apparently rapidly contracting earth, explosive speed, exploration of space, the vast potentiality of the new psychologies, broader and deeper awareness of other cultures and their intertwined history, the struggle for democracy, competing modes of social structure, the mushrooming of events —all of these have affected the possibilities of artistic resource.

One of the greatest changes came about through the development of communications; as photography, motion pictures, radio, and television developed, painting became less dominant as a means of public expression and tended to become more personally expressive. In the process it has acquired a more significant social role. To its age-old role as an important expressive vehicle of discoveries about life, it has added that of reasserting the individual in a society threatened by mass means and ends. It also helps to transform society by transforming the individual.

It was nineteenth-century impressionism, with its analytical use of color to match the sensation of light, that opened the Pandora's box of art. The tiny dots of the impressionists became dashes that rapidly exploded into massive contrasts. The impressionists' direct painting from nature burst all conventional fetters, as did their negation of shape and relative formlessness.

87

PLATE 45

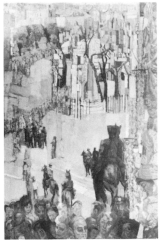

PARADE

Collection of Whitney Museum

QUARTET

Collection of Mr. and Mrs. Hayward Cirker

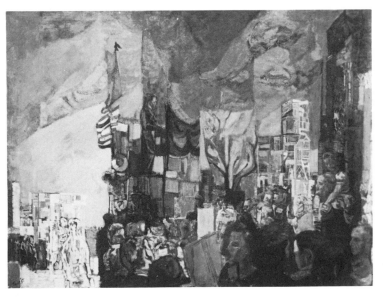

MEETING

Dr. and Mrs. Howard Marmelstein

WASHINGTON SQUARE

Private Collection

*Art stems from and embodies life even
as it becomes itself a new reality.*

PRE-COUNTDOWN

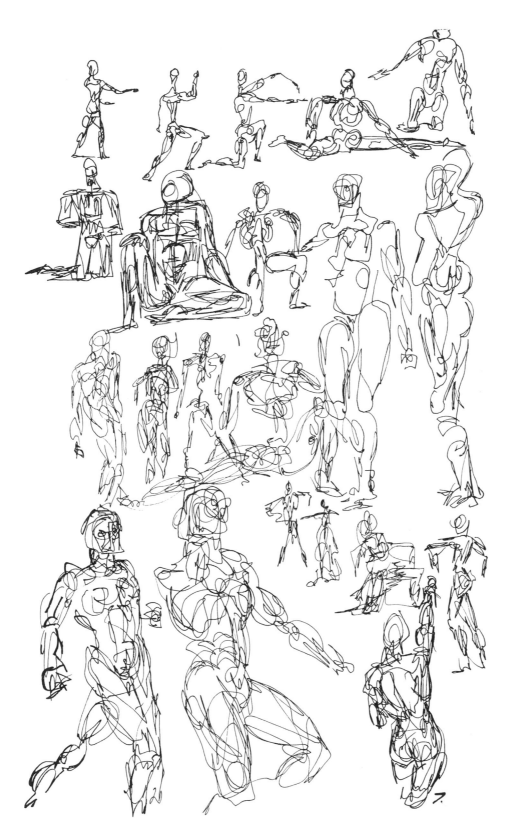

PLATE 46

Draw free variations of the figure from imagination without concern for accuracy.
Allow the line to ramble, express what it will.

PLATE 47. COMPOSITION
Experiment with what happens to paint. Blot it, drop it, let it run, let a rich accident
develop. Sense the organizational possibilities. Respond to plastic ideas suggested,
reinforcing some, negating others until a sense of resolution is attained.

PLATE 48
Doodling: cultivate the habit of drawing while your attention is elsewhere.

The resulting problems and boundless opportunities blew the structure of art into fragments, each of which has nurtured far-flung experimentation ever since. In striving for the world of appearance, the naturalists, ironically, freed painting from it.

Since that time movements have followed one another with increasing rapidity. This vast panorama becomes a strong influence leading at once to possible confusion and to greater range and richness of experience and possible synthesis.

The discoveries that came out of the experiments of the last century are inevitably among our resources. Particularly as the student or artist enters the initial phase of the creative process can he find new ways of exploring the many-sidedness of the problem that confronts him.

These discoveries involve stress upon various aspects of the levels of meaning embodied in a work. We have already named some of the initial phases of the creative process; we will now explore these resources more fully as they apply to the art of painting itself.

The Investigation of the Problem

The period in the creative process in which the painter explores the problem is the freest and perhaps the richest, most carefree phase of the work. One's goal is not yet fixed; the difficulties are not yet seen. The perception of the problem, therefore, is a period of exhilaration matched only by the profound satisfaction of eventually finding a solution.

The searching out of a problem will be influenced by one's previous work, experience, and expression involving visual contrasts, organization, and imagination. Previous painting can sometimes establish the particular ideas of the work and thus telescope the entire creative process. The reaction of others also plays a role, as does what others are doing or have done.

Painters tend to work continuously, looking in plastic terms, subtracting or adding qualities to visual stimulation that become painting ideas. In general, the artist works as he must, though he may consciously attempt to contradict his past habit patterns in order to establish a new direction. To this end he may seek to create obstacles or accidents, even to court failure, in order to be forced to find new ideas.

Toward the clarification of the problem, many methods are consciously or unconsciously employed—those of trial and error, analysis, separation and reconstruction following reconstruction. For the painter these may occur directly on the canvas, or through sketches and studies, or in thought. The important thing is for him to remain flexible, feel free to try many paths, and be bound only by the gradually revealed nature of the problem itself.

Psychological Association as a Source of Ideas

One of the painter's fundamental sources for plastic ideas is that of his own rich labyrinth of memory. Here, in the less conscious levels of remembered

PLATE 49. THE MONSTER (Drawing)
Juxtapose related and even unrelated images.

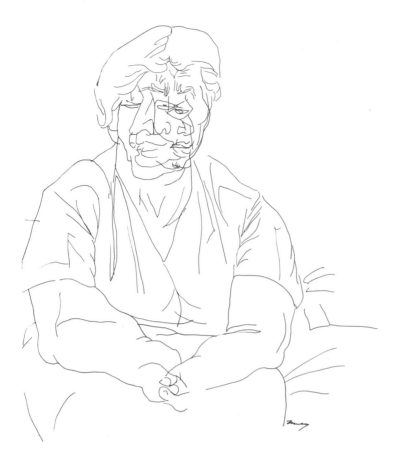

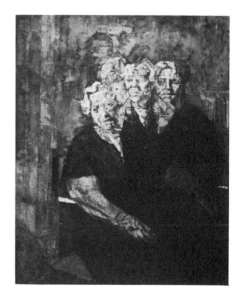

FRIEDA

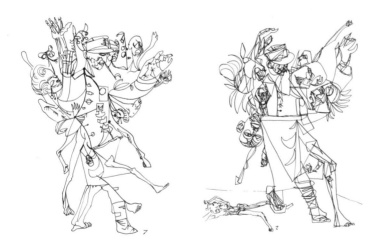

PLATE 50
Juxtapose images in unexpected ways. Allow them to develop spontaneously as in a stream of consciousness.

experience, are associations which can be aroused by cues in visual contrasts. Such associations are not only personal but, because of our overlapping experience, social as well. They are often obscure and multiple as they emerge from a dynamic labyrinth of changing memory strongly influenced by current impact, need, and relative strength.

While all visual contrasts arouse associations, they may in a work of art be consciously stimulated. They are aspects of one's first-level signal system, of conditioning that makes possible the more conscious level of symbolism.

Among the exercises which will prove a rich means of mining this personal resource is that of using accident or chance, as in spontaneous, automatic play involving some or all of the visual elements of line, shape, color, texture, value, and space. Accordingly, put paint on haphazardly, blot it, then put on another layer. Pour various colors; try any idea that suggests itself; make it a rich accident full of contrasts. Then analyze the suggestions, both plastic and psychological. What relationships are most often repeated? What is suggested in regard to a subject? What kind of mood or feeling? Does it give you an idea to develop further?

On nature walks watch for nature's accidents, its odd suggestive juxtapositions and weather-beaten materials. Our whole environment is filled with accidental configurations that are pregnant with ideas. Some of these are shown in photographs; others are the result of hidden processes of chemical change or decay. Allow yourself to dream, to see, to project, to analyze.

Doodling is a particular form of accidental drawing. Whenever possible, cultivate the practice of simply allowing your hands to move over the paper at will while your attention is somewhere else. Later the drawing may be important to you.

In a similar manner, juxtapose images in unexpected ways. Allow them to develop spontaneously as in a stream of consciousness, drawing them as they occur to you, symbolically or illusionistically. Try montage with these drawings or use them separately. Keep suggestive scraps to use in such contrasts, remembering that unusable ideas may become important ideas another time. In these ways the labyrinth of psychological associations can become a rich source of ideas in your work.

The Cross-Fertilization of Ideas

The pattern of human growth and change may be simplified as follows: the human being transforms experience into ideas; such ideas cross with one another and lead to new concepts; these, tested in practice, create new experiences that lead to further transformation. In this process the accidental or contrived crossing of ideas is the painter's opportunity to escape previous patterns and discover new possibilities in painting. It undermines determinism by suggesting a measure of choice; its unforeseen, unexpected qualities may disrupt previous memory paths and cause a reorientation in the painter.

Cross-fertilization thus breaks the relative rigidity of conditioned habit

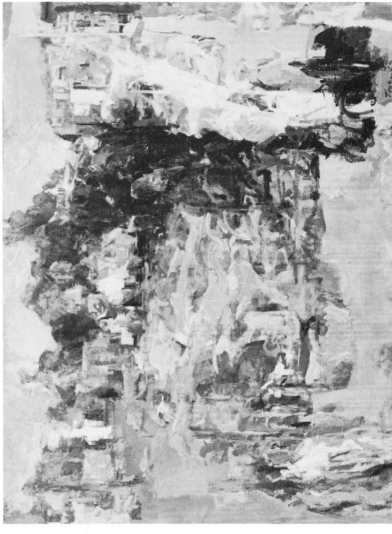

PLATE 51

Cross-fertilization breaks the relative rigidity of conditioned habit. Flexibility, exploration, and observation encourage such crossings.

MOUNT KISCO

Photograph by Colten

WOMEN OF KILL VAN KULL

PLATE 52

ANNLEE AND HERZL

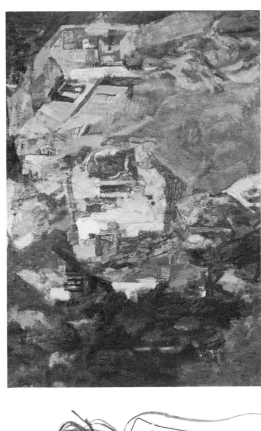

Collection of Mr. and Mrs. Herzl Emanuel

*Automatic drawing and doodling are effective means for probing
the self and disclosing unusual cross-fertilizations of ideas.*

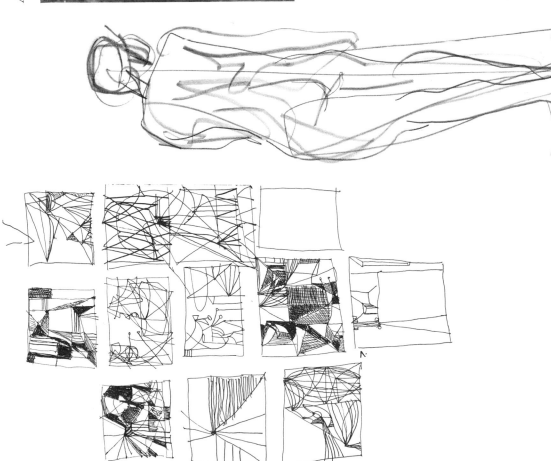

PLATE 53. NUDE
Allow contours to overlap. Repeat figures in different ways for rhythmic movement and to create spatial interest.

which can constrict or stifle the creative process. It creates imagination, fantasy, and invention. Flexibility, exploration, observation, and the search for many-sided qualities encourage such crossings, even as formalism and academicism tend to restrict them.

This process occurs constantly, seemingly uncontrolled yet controlled. Some control is necessary, since imagination can become not only irrelevant but dangerous if it leads us away from rather than to reality. We do not know, furthermore, the import of some of the ideas that evolve. The mechanism for control is our expanded and tested awareness.

It is this relationship of forces within the dynamic labyrinth of memory and thought that determines what discoveries will or will not be recognized. This changing synthesis is our level of awareness.

Works of the dadaists, the surrealists, and such works as magic objects, collages, and montages are more obvious examples of the process of cross-fertilization, while cubism is a less obvious example. All art, however, depends upon this process.

Psychological Distortion

One means of investigating and controlling the material with which you work is that of psychological distortions of size, texture, and other visual contrasts. In your drawings, for example, make heads larger and watch the effect. How do they feel? Making parts of the body expand or contract can intensify feelings of space, power, and movement. Manipulate the contrasts in all ways.

Build your images with montage or collage materials, figures of bits of scraps, the whole scene. If you are painting a figure, paint it as though it were a landscape or city; if you are painting a landscape, paint it as though it were a figure or groups of figures. Do not be afraid to project associations. The relationships that result will become richer and more meaningful.

In your work seek out the sense of mood. What does joy or sorrow look like? What are their colors or textures? Experiment with various configurations and base yourself on your own reactions.

What does a sound look like, or a scream? Listen to music. Do the sounds suggest visual configurations? Work freely, with abandon, automatically.

Allow your drawings to be extremely free, with contours overlapping. Do not erase. If you lose your way, put the drawing aside for a while and work on something else; it will later become clearer. The confusion itself will turn into ideas for exciting transformations.

In everything, exaggerate what interests you. Most of us do this anyway. It sets up a psychological order that can become the basis of a plastic one. Allow the very character of your touch to express your feelings. Put the paint on the way you feel it.

Do not hesitate to be consciously autobiographical. State what you wish,

PLATE 54

BEFORE THE FIREPLACE

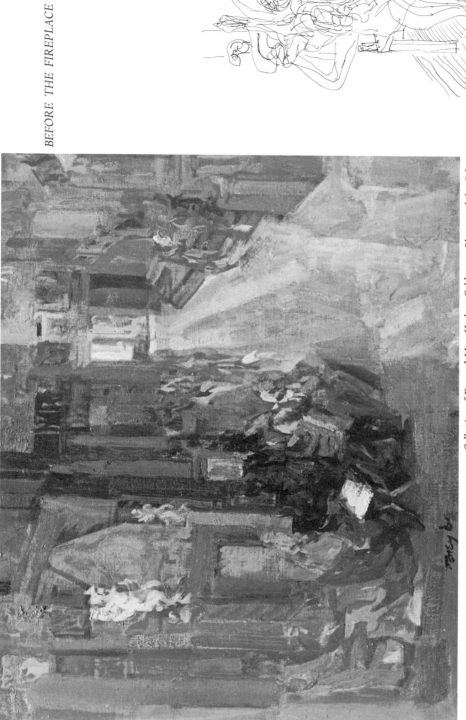

Draw from memory, events, places, or images of feelings. Exaggerate or distort to express mood.

Collection of Dr. and Mrs. Herbert Goldman. Photograph by Colten

PLATE 55
Allow your line to roam freely. Try the same subject over and over in different ways.

PLATE 56
Be consciously autobiographical. Draw symbolically.

Juxtapose images in contrasting ways. Improvise ways of making similar things different.

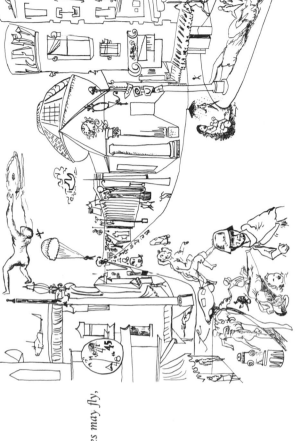

Natural law need not tie you down. Figures may fly, take any form or shape.

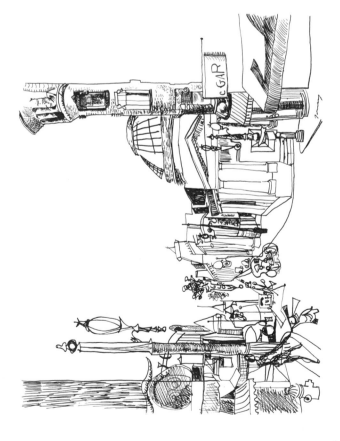

PLATE 57

Private Collection. Photograph by Osti

VICTIMS

If strongly moved by life situations, try them out on paper. Experiment with various ways to express what you feel.

PLATE 58

symbolically or otherwise; natural law need not tie you down. If your figures tend to fly or take various forms or shapes, let them. They can at once go forward and backward into infinity.

If, finally, you are strongly moved by life situations, whether your own or those of others or in newspaper accounts, try out these situations on paper. What do each of them look like? Try one idea in many ways, always remembering the discoveries that distortion can produce.

Symbolism

In painting or drawing symbolism consists simply of configurations, illusionistic or otherwise, that stand for various meanings, experiences, or relationships. In any discourse the use of symbols opens up the broadest type of ideological generalization as well as the most intimate communication; in art it provides also for the most sweeping kinds of cross-fertilizations.

There are two kinds of symbolic references in art. The painting may be symbolic in the sense in which the name of a person stands for that person—what we might call particular symbolism. Or it may be symbolic in a conceptual way, as in the case of such general nouns as "property" or "truth." Naturalism lends itself to particular symbolism, using a configuration that refers to a particular event or person in various ways, even to the extent of fooling the eye in some instances. Classicism, romanticism, and realism, on the other hand, are more likely to use a conceptual symbolism that aims toward the universal rather than the particular.

Particular symbolism in painting and drawing is involved in any representation of a person, place, or event, contemporary or historical. Conceptual symbolism may use figure images to stand for universal concepts such as truth or love. Also conceptual symbolism utilizes geometric signs, shapes, letters of the alphabet and words, psychologically motivated color and distortions in many visual symbols, trade marks, and the like, from everyday life. The painting structure itself becomes a conceptual symbol as it reveals the painter's attitude and concept of reality.

Symbols are learned, formally or informally, but transformations in our lives change our symbols as well. The "pop" artists often succeed in giving fresh meanings, usually satirical, to old symbols or clichés by stressing them out of context. The individual symbol has a social context and easily becomes a social symbol. Collectively we bring new discoveries, new symbols, into being even as the old are being revised, resurrected, or discarded.

Research, serious or casual, may bring to light old signs that will stimulate the artist to new symbolic syntheses. The artist extends and deepens both his discoveries and meaningful impact through the use of particular and conceptual symbolism.

Illusion

The level of illusion, or the naturalistic observation of appearance, is one of the painter's most important resources for ideas. It is based on a close

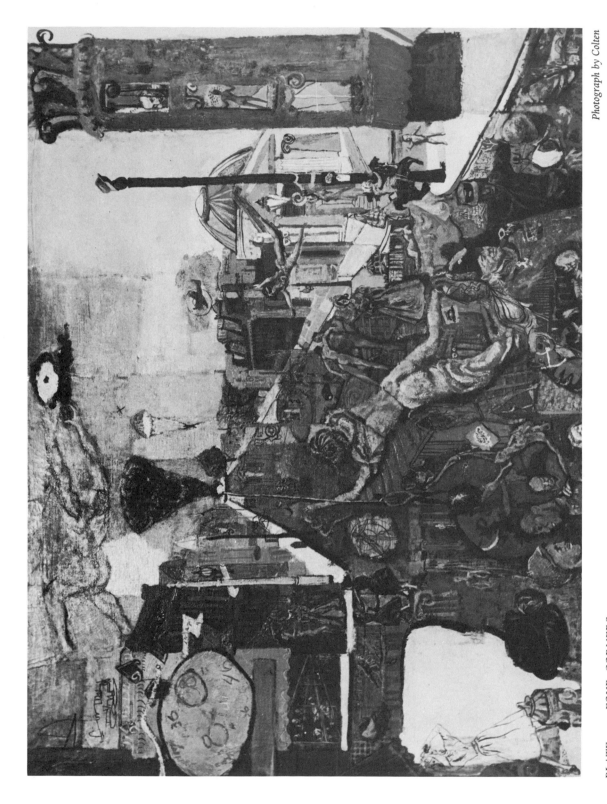

PLATE 59. FOUR CORNERS

The painting is a montage-like stream-of-consciousness web of images, aimed to stir cross-fertilization of associations and symbolic meaning.

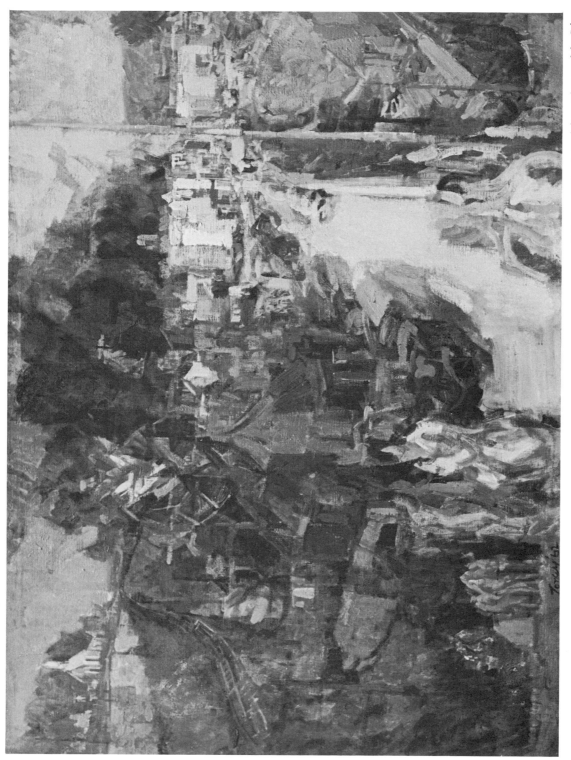

PLATE 60. CARNIVAL IN MOUNT KISCO
There are two kinds of symbolic references: the painting can stand for the person or thing painted or for generalizations and concepts.

Collection of Mrs. A. Michelson. Photograph by Colten

PLATE 61

MISSY

The study of nature, whether in the figure, head or environment, can lead to personal and psychological levels of meaning as well as structural ones.

Collection of Mrs. Connie Jo Di Cruttalo

FIGURE IN PINK INTERIOR

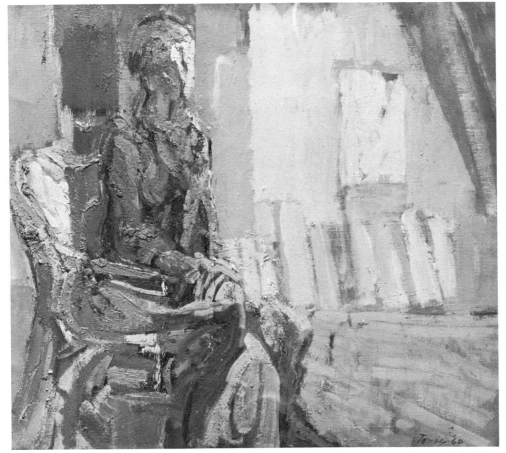

Photograph by Colten

(facing page) An opposition of variations of yellow and blue is at work in this canvas. The triangular thrust of varied light yellows pierces the blue, cutting it into two triangular areas. Both the blues and whitish yellows mix to obtain more complex gray variations. The yellow reaches its climax at lower left of center, where are also the brightest white, darkest dark, and counterassertion of red.

Collection of Mr. and Mrs. Robert Runyan

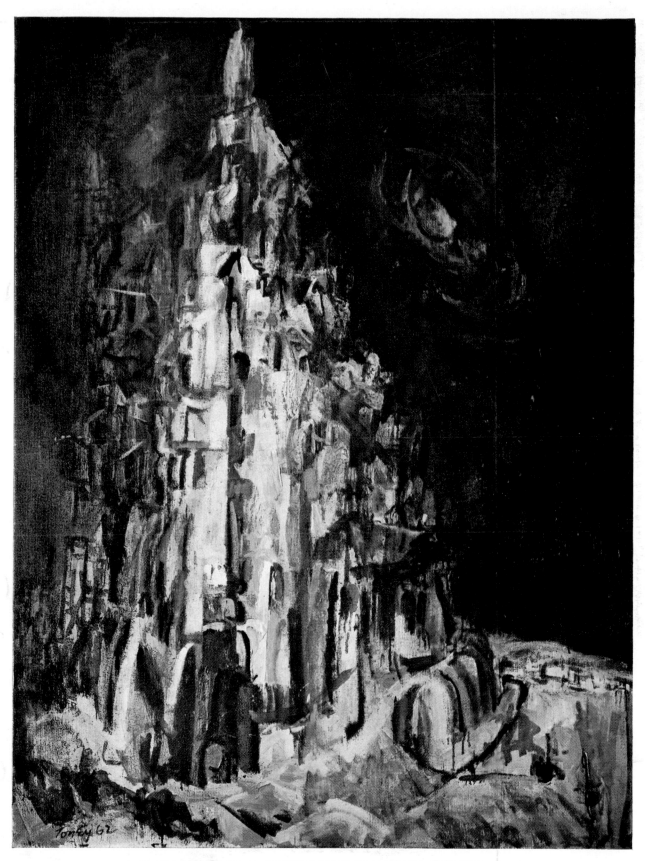

TOWER OF BABEL AFTER BRUEGHEL

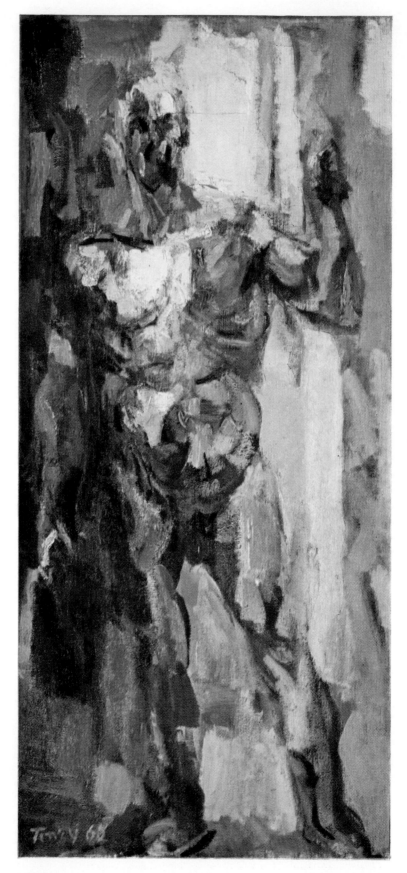

MAN

PLATE 62
Draw as much as possible from the live model, using quick poses and longer ones.

(facing page) A main theme of variations of blues and blue-grays progressing from dark blue-black to white dominates this painting. The countertheme: warm reds ranging from red medium to orange, from dark brown and purple to light pinks. Yellow intervenes subordinately to form gray yellow-greens. Red opposition is dominantly expressed at lower left but permeates whole in minor nuances. The blue is intense at upper left, helping to establish left strong dark rectangular thrust and reinforcing climax at white or near-white area just below neck.

PLATE 63

Draw freely or closely from anatomical studies.

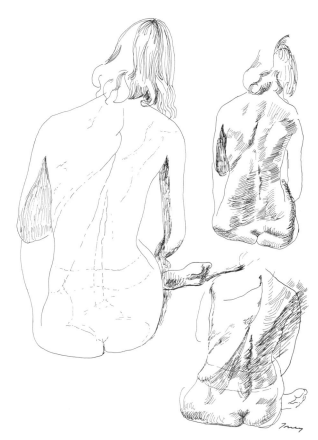

Search for anatomical relationships
from the model.

observation of nature and the development of the skills necessary to render nature's correspondences. The study of appearance paves the way to its penetration. Illusion depends upon recognition. If one has experienced the object, its illusion or natural representation communicates immediately.

In your work make many drawings of the way things actually look. Study their structure. Even though your own goal may not be naturalistic, you will find what you learn useful.

Work much from life, from the nude. Study the anatomical relationships and the way cloth drapes over the figure. Study and make sketches of life situations; carry a pad and jot down relationships as they occur.

Study the structure of animals and plants as well. How do animals move? How are the parts of plants related? Linear perspective* can help you to learn to control your space. Experiment with it as a source of creative ideas. Atmosphere is a strong influence. Atmosphere and light affect all the other relationships, particularly those of color.

Begin also to experiment with impressionist exercises. Use dots and dashes of various values of primary colors. First establish your value contrasts in a thin underpainting; then after it is dry apply the dots, trying to analyze each color into its relative amounts of red, yellow, or blue. Do not mix the colors; let the eye do it at a distance.

Try sketching rapidly the effects of nature directly. Establish the largest contrasts quickly and then some of the details, but keep the work broad. Do not pick at it or worry it. Try to sense the general color and value contrasts and to match them.

Sensibility and Structure

Contemporary experiments in their search for painting resources have emphasized at various times both the levels of sensibility and structure. The two are closely related, but emphasizing one or another can result in paintings as different as those of the action painters and Mondrian.

The level of *sensibility*, essential to all drawings and painting, may be said to be the action of direct experience upon the nervous system. While other levels are involved in painting, none is more necessary than this, and nowhere is it more easily explored and more flexible than in the plastic arts, where it is experienced as the direct communication of the force relationships. While in life this direct impact is common, in art it is controlled and contrived to arouse, satisfy, and move the viewer.

As a painter you must become conscious of the sensuous effects of contrasts upon your own sensibility. Experiment with simple, limited problems. Can you, for instance, juxtapose only two colors and establish an exciting relationship? Keep one color area larger than the other. Superimpose one choice after another, remembering your awareness of each effect. Take a single idea and try various combinations of value and color to test its interest

* See Chapter VII, pp. 143–146.

PLATE 64

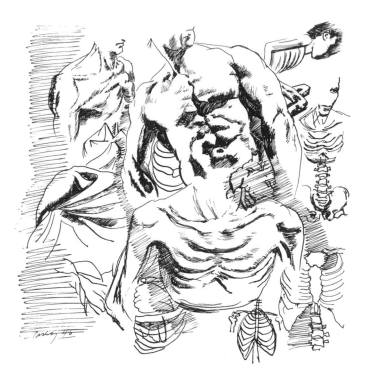

The study of natural structure reveals visual contrasts that become plastic ideas.

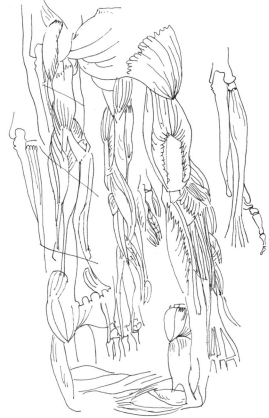

Study the connections and interconnections of bone and muscle structure.

PLATE 65

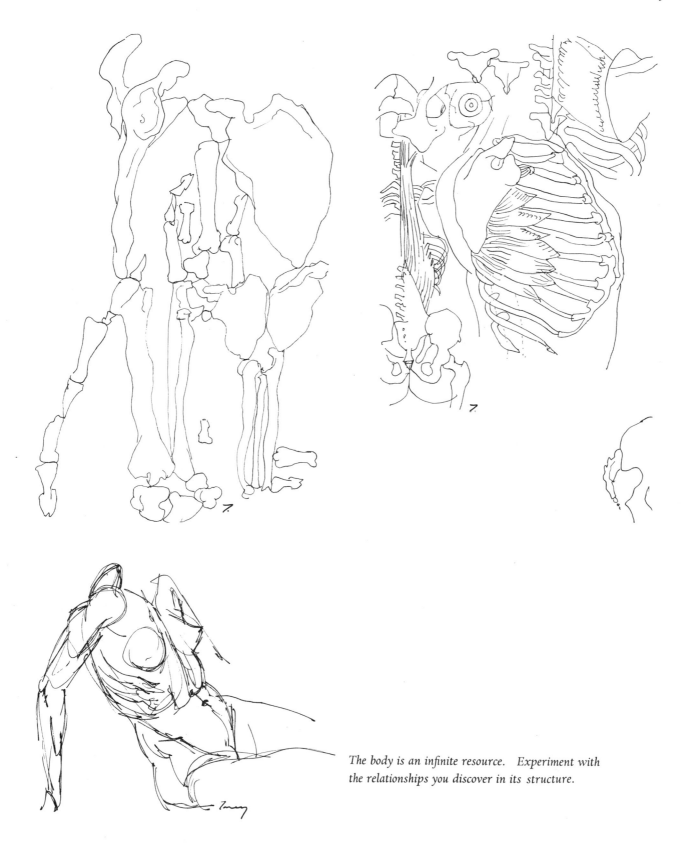

*The body is an infinite resource. Experiment with
the relationships you discover in its structure.*

PLATE 66

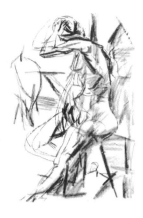

Contrast in nature—in the body and its environment—can be transformed into an organic visual structure.

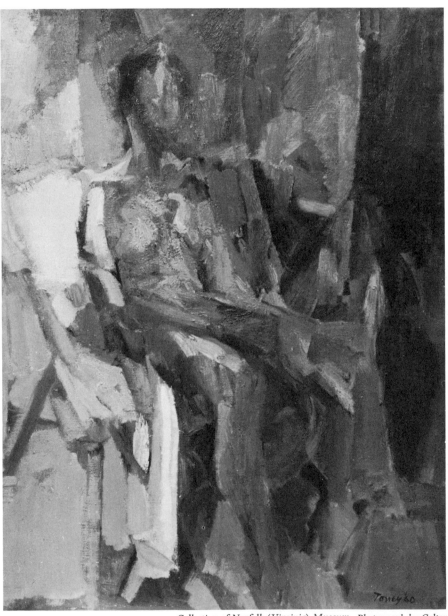

WOMAN IN BROWN *Collection of Norfolk (Virginia) Museum. Photograph by Colten*

PLATE 67

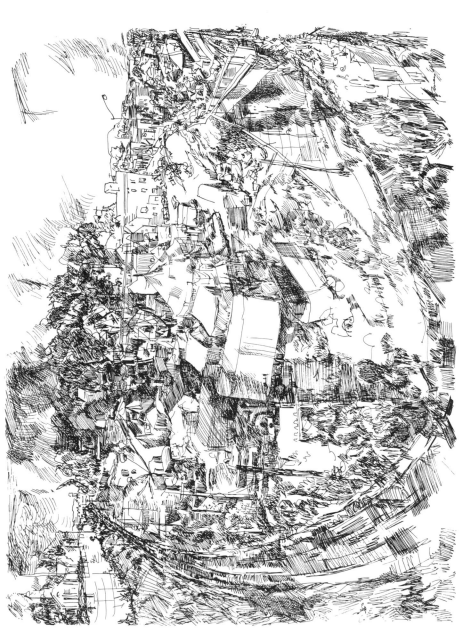

CARNIVAL IN MOUNT KISCO (Drawing)
Carry a sketch pad. Jot down rapid notes whenever opportunities occur. Make more detailed drawings as well.

PLATE 68
Study the structure of animals and plants.

Become conscious of the sensuous effects of visual contrasts upon your sensibility. Try one combination after another and compare the results.

PLATE 69. QUARTET

and excitement for you. Your sensibility will react, but your awareness of that sensibility will need to be developed.

As you go to galleries become attentive to the impact that physical contrasts make upon you. Compare your judgments then with the evaluations of others.

The level of *structure*, on the other hand, is that which involves the actual organization of the work. Without a plastic structure a painting is not a whole. Organization resolves the contradictions in the work.

The artist as a person incorporates various resources which provide the body and spirit of his work, resources that are both contradictory and complex. This complexity is made up of still simpler oppositions, visual and otherwise.

In every work both psychological (or ideological) and visual aspects are intertwined. The base of material experience is transformed into the painter's subjectivity, to become visual contrast. While the artist organizes both, it is primarily the visual organization that makes the work a drawing or painting. A few of the elements involved in this process are listed here.

The visual oppositions or contrasts (such as black, white; straight, curved; red, blue; far, near, and so on) are plastic since they can be manipulated. In painting and drawing the word ''plastic'' thus refers primarily to visual contrasts.

The basic visual elements are line, shape, color, texture, value, and space. Primary oppositions of these elements are their basic extremes (e.g., black, white, as listed above) or geometrical aspects (e.g., triangle, rectangle, circle).

The primary oppositions of a work may be disentangled from its complexities through simple visual comparison. Through an awareness of the simplicity inherent within the complexity, the latter is controlled and transformed.

Finally, main, minor, and opposition ideas or visual themes are extracted, moved through the work with variation, and held within a pattern to reach some sort of climax or equilibrium. The solution or resolution is final for the work but temporary for the artist.

In the following chapters we will discuss structure in more detail. A few brief exercises, however, will suggest ways of becoming more sensitive to it.

Exercises that stress one or another visual element are useful. Extract, for instance, all the vertical continuities, all the movements that line up, but state them with variation as in analytical cubism. Any other direction can be substituted. Draw from nature. Look for the regularities, for geometric similarities, and state them, whether implicit or explicit. Are most of the shapes triangular? What kind of shapes predominate?

As you look at pictures or reproductions, examine their main direction, their shape and pattern similarities and contrasts. Notice where they seem most intense. Are there some that seem out of place?

Take a simple form, a triangle or star. Repeat it again and again, trying to

PLATE 70

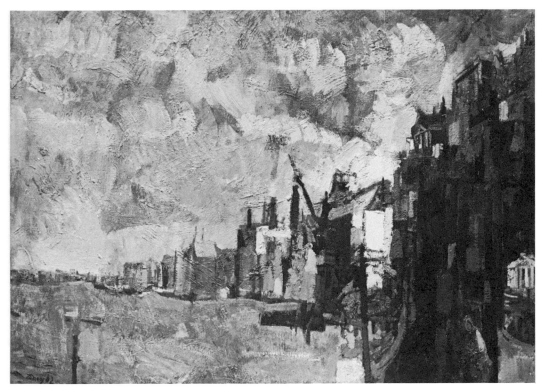

STATEN ISLAND COAST *Photograph by Colten*

Superimpose one color choice after another with awareness of each effect. Keep patterns bold and strong.

WATERFRONT

Collection of George Schiller. Photographs by Colten

PLATE 71

Extract plastic similarities from natural structures. Repeat with variations. Thematic sequences are your main organizational means.

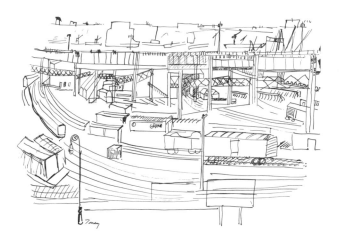

Structure of a painting or drawing is organization of visual relationships. Become sensitive to visual regularities.

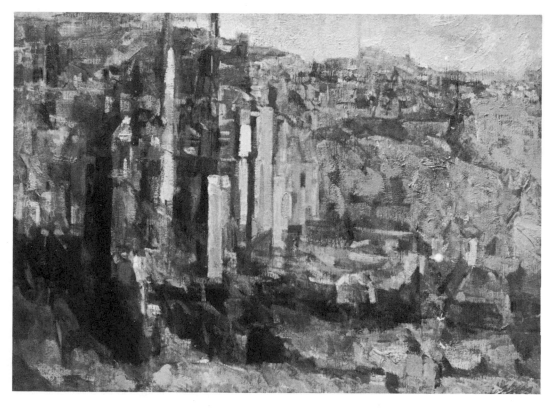

AMSTERDAM

PLATE 72

When drawing a figure align the parts of the body with one another and with the surrounding area.

BATHERS

Collection of Roy Neuberger

PLATE 73
The artist's morgue can be an important visual record of experience reflecting the scope and complexity of the modern world.

find every possible variation. Do the same thing with a figure shape. Such exercises may give you ideas for more fully developed works.

Try in some exercises to extract a geometry as pure and limited as Mondrian's simplest. In others try for more associative shapes and more complicated situations as in Miró or Klee.

As you work, make certain that one area is most intense and dominant. Experiment with possible kinds of climaxes or centers of interest. Make up exercises of your own which will sharply call your attention to one or another significant structural factor. Becoming aware of the structure of things will help you to organize your work in other ways as well.

Morgue

Among the artist's research resources is that of a morgue—a collection of photographs, illustrations, and other visual materials kept for use as needed. He may make use of his own morgue or one like that of the New York Public Library, where visual material can be referred to or borrowed.

The artist's morgue may be organized or haphazard. It may consist simply of portfolios of drawings, pads, and other material, including perhaps such representations as doodles, fragments of description or ideas, sketches, studies from life, and finished drawings. The artist may, however, also have such other materials as photographs, reproductions, magazine illustrations, slides, news items, and the like. The more organized morgue will have such material in files under appropriate headings.

Some artists may get a vague idea and proceed to do casual but persistent research, gradually accumulating visual and other facts in folders until the time is right for further development. Certain historical, public, illustrative murals and other work may require much searching for specific facts.

Such use of materials has a long tradition. Brueghel depended much upon drawings made on his Alpine journey, and Rubens freely used drawings from antique sculpture. Such research was often based on previous art work; even today artists often take a work or photograph of it as a point of departure for a new work. In this sense, museums and galleries are morgues of art of the past and present, and are important for every sort of research, technical as well as visual.

I am still using drawings made many years ago as well as current ones. You should develop the practice of carrying a pad and noting useful ideas as they occur. Later, organize them in some sort of way that will provide easy reference.

The Thumbnail Sketch

The small or tiny sketch is an efficient means of seeking out the possibilities of an idea. In the early stages it is better if your sketches are small, so that they involve less time and energy and leave you free to move from one to another. Keep them general, mostly sketches of ideas, showing size, placement, main

PLATE 74
Save your figure drawings in an organized way. They are resources of ideas.

Draw quickly and directly from life experiences.
Each fragment can enrich your morgue of drawings.

PLATE 75

PLATE 76
Thumbnail sketches show relative size, placement, main gestures, dark and light pattern.

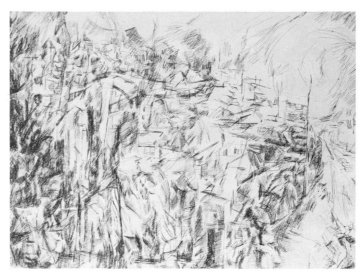

YONKERS

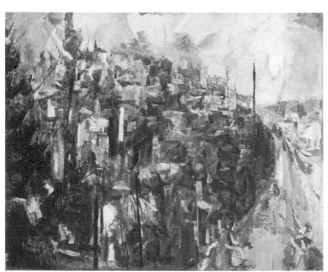

Similar resources yield different plastic ideas.

OVERLOOKING YONKERS

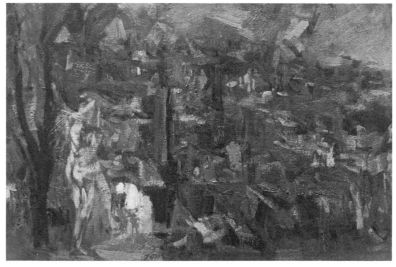

PLATE 77

Photograph by Colten

gestures, dark and light masses, and possible pattern. Do many of them in all possible ways.

As particular relationships attract your attention, carry them out on a larger scale. Elaborate the whole and its parts, carrying out further studies that suggest themselves. Ideas may occur which will not now be workable. Save them for other times, to seed later paintings and drawings.

Color sketches on a small scale are also valuable. Try out the main color possibilities, then elaborate on them. If small paintings result, so much the better. The more concentration a particular idea can withstand and still sustain interest, the more meaningful it will be to you. Color sketches can also be montages of colored scraps. Pasting bits of paper sometimes seems easier and produces exciting suggestions; you should have paper scraps available, therefore, for such use.

Color sketches can be done in any of the media such as watercolor or oil or in the combination materials in pencil or stick form. All that you do should become additions to your morgue or portfolios of drawings.

Conclusion

The period of exploration may be a relatively short one or a longer one in which many possibilities are searched out before a decision is made. In this chapter some available ways have been suggested—basic approaches, possible ideas that come from the rich plastic discoveries of contemporary art—not as formulas to be followed mechanically but as aids widening and enriching this exploratory period.

It is, after all, the preliminary exploration which gives us the generalizations, cross-fertilizations, and insights that complete the work. The language of painting is essentially the organization of visual elements, plastic forces that affect the sensibility and mind.

At this point, however, difficulties arise. We are not aware of the elements of this language apart from their various meanings. Plastic organization thus becomes mired in conflicting purposes. It is little wonder that some artists have tried to divorce structure from all other meaning, or have become bored with a concern for abstracted elements and concepts of visual organization.

Both the romantic and naturalistic traditions tend to negate any such concern for concepts of design or structure. For the romantic such a concept is already dead when stated and worthless in satisfying his need for freshness; the naturalist is already dedicated to the structure of nature as it appears to him, and any other set of concepts becomes an impediment.

Yet it is precisely structural necessity and realization that turn a work into a work of art, however this is achieved. It becomes important, therefore, to look more closely at the nature of the language that composes the plastic structure and, first of all, its elements.

These elements are the essential visual contrasts. For the purposes of this book they are limited to six: line, shape, space, value, color, and texture. Each of these will be explored in detail in the following chapters.

PART III
THE LANGUAGE OF VISUAL DISCOVERY

CHAPTER VII
ELEMENTS: LINE, SHAPE, SPACE, VALUE

Line

Line can be thought of either as the separation between one thing and another, or as the direction of a series of planes or their movement. Considered as movement, lines differ in regard to straightness and curvedness, verticality, horizontality, and circularity of direction. The diagonal becomes a variation of these.

Line can be implicit or explicit. An implicit line is a hidden one, revealed only by similarity, as when otherwise separate things or their parts line up in some way. An explicit line is its actual direction or combination of directions. In practice, lines are at once implicit and explicit: each has its one precise direction while functioning implicitly with others.

Continuity of direction refers to the implicit movement of line. Similarity of direction refers to those which repeat the same or similar direction in relatively parallel ways. Complex directions can be seen more readily if they are compared to simpler ones. Their complexity breaks down into principal and subordinate components of curved, vertical, and horizontal directions.

In the very nature of line exist the painter's two main modes of working—the movement of gesture and the contour of shape.

Shape

In any art work shapes are masses of varying size, value, or color. They are essentially triangular, rectangular, circular, or some combination of these.

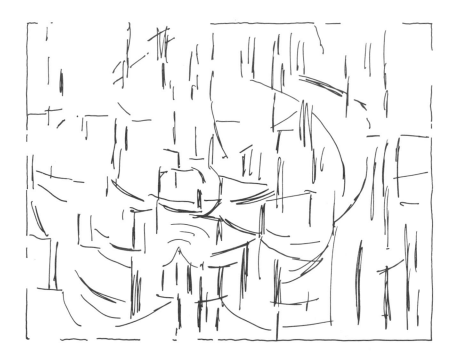

Primary directions

Primary shapes

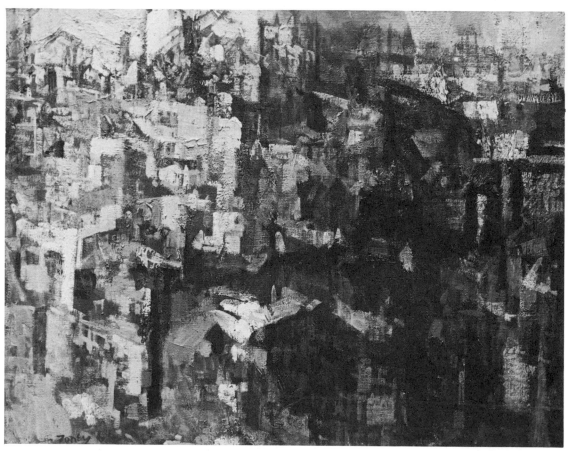

Private Collection. Photograph by Colten

PLATE 78. OVERLOOKING LOWER MANHATTAN

Continuity of direction: in this picture implicit vertical, circular and horizontal directions line up to form rectangular and circular shapes.

Actual or explicit directions and shapes in the work below.

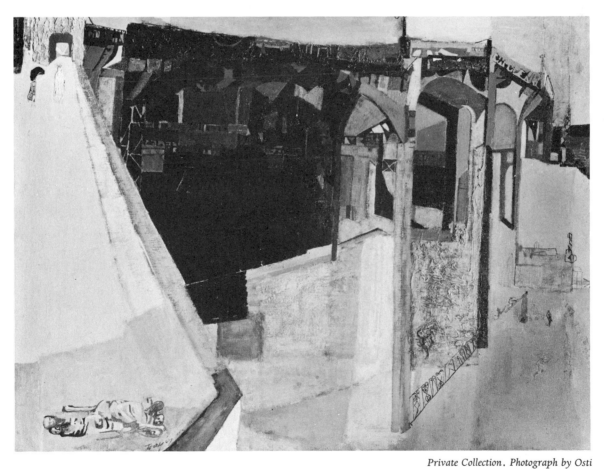

Private Collection. Photograph by Osti

PLATE 79. RIVERSIDE DRIVE
Similar directions are those which are relatively parallel; complex shapes are aggregates of simpler ones.

Overlying actual or explicit shapes and simpler implicit shapes. Complexity and simplicity are counterpointed.

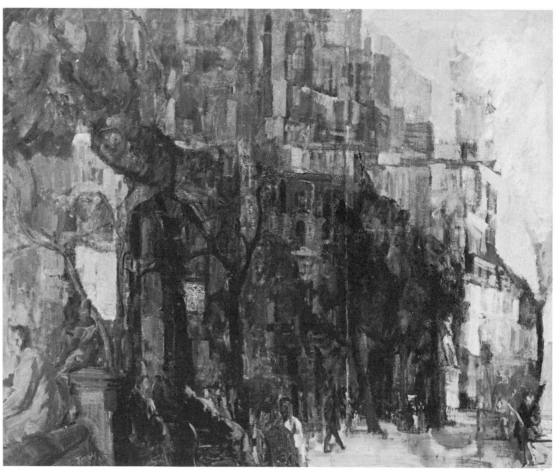

Private Collection. Photograph by Colten

PLATE 80. *WASHINGTON SQUARE*

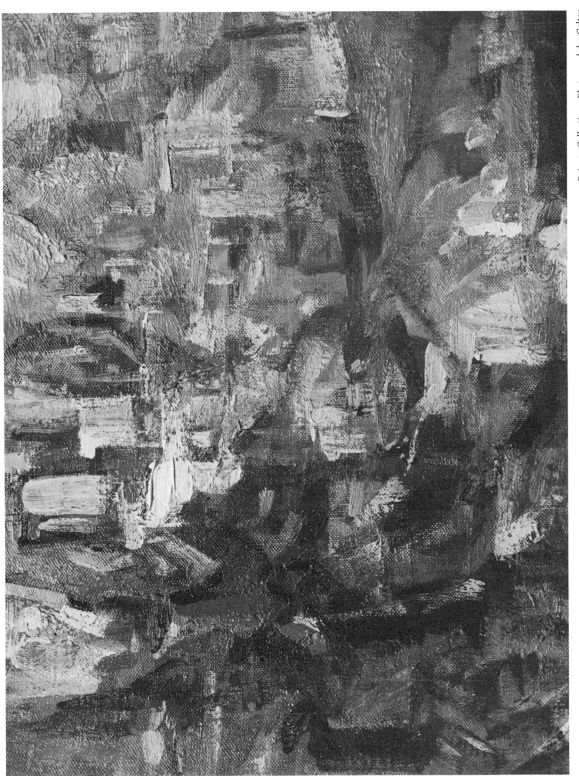

PLATE 81. U.N. FROM QUEENS
Shapes of one value act as planes coming forward or retreating, occupying specific positions in the space context.

An explicit shape is that area which is within the actual contour. Implicit shapes, on the other hand, are those revealed by implicit line or direction. Similarities of value, color, and spatial position help create implicit shape relationships; they create overriding patterns that unite many smaller shapes into new and larger ones.

A shape will usually refer to one or another primary shape, and complex shapes are combinations of primary shapes revealed through comparison. Extracting and stating the primary shape makes it easier to relate the remaining parts. This dominant aspect is implicit within each shape.

Shapes act as planes in relation to other shapes, either coming forward or retreating or moving in one way or another. They occupy specific positions within the space context.

Space

In art as in nature, space consists of the position of planes—flat surfaces, varying in size, that tend to recede, come forward, or stay put within any particular context. In nature each plane is different in color and value from those about it. Similarly, in paintings, each plane must at least seem different or work differently from any other.

This contrast in position in space is determined by relative strength or force relationships* as well as illusionistic ones. These may exist together or the former may exist alone. All illusionistic space possesses force relationships as well.

The extremes of movement of planes away from or to the viewer and the middle position are called primary positions. All other positions are variations of these.

Primary qualities of three-dimensional or illusionistic space consist of the oppositions of the sphere, pyramid, or cube. More complex three-dimensional forms are combinations of these. Natural space is expressed through linear and aerial perspective, which we will now consider in some detail.

Aerial Perspective

Atmospheric or aerial perspective refers to the effect of varying thickness of atmosphere upon sight. When something is moved farther away from the observer, it appears less distinct, less intense, and also smaller. Whatever local color or value it had moves toward neutrality. The closer anything is, on the other hand, the darker or lighter, the more intense, more distinct, and larger it tends to be. The use of atmospheric perspective is thus one of the basic means in painting of creating the illusion of space.

Volumes are best revealed if there is one main source of light which is high and almost frontal. Many sources of light confuse the relationships. Since volumes appear to us because some of their planes receive light and others do not, we could theoretically flatten the appearance of any volume, given

* See "Actual Space," pp. 150–153, for a fuller discussion of force relationships.

PLATE 82

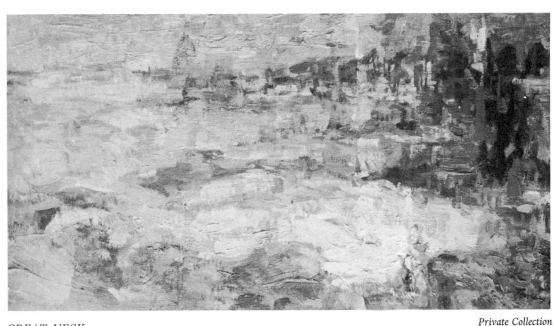

GREAT NECK

Private Collection

Aerial perspective refers to effect of varying thickness of atmosphere upon sight.
Colors become less bright, and black and white become medium gray as they retreat.

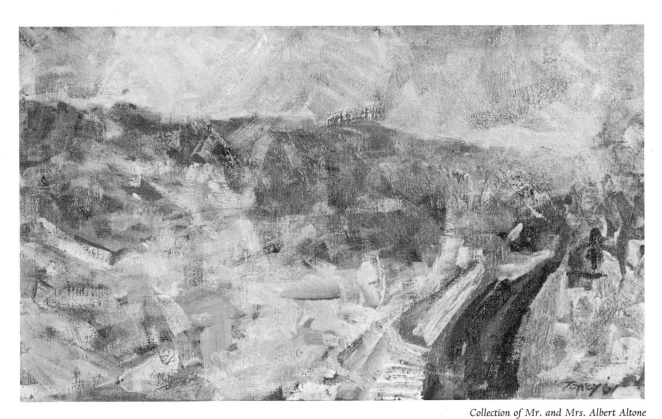

Collection of Mr. and Mrs. Albert Altone

LOOKING TOWARD KATONAH

Space in plastic works consists of a system of spots and areas of color and value that
act as planes which compete with each other. Because of their difference in relative
strength some seem to come forward and some to retreat.

enough light sources. Direct light is the strongest. Volumes, however, also receive light from indirect sources—reflections of light (and therefore of color) from other volumes and planes.

Given a main source of light as indicated above, the nearest plane of the dark side of the volume will appear darkest. The inner area of the dark side, which receives reflected light, will be lighter. Reflected light cannot be as strong as direct light.

Likewise, those parts of the light area that are closest to the observer and to the source of the light will be lightest. The middle areas will be generally less light, since their planes turn away from the observer. These areas also lose intensity and change value as they are influenced by reflection from other surfaces.

The lightest and darkest forward planes are called turning planes in that they turn decisively at some one point from light to dark. Shadows generally are lighter within their edges, and the edges consequently appear darker.

The extreme edges of volumes will be light or dark depending upon the value behind the edge. When representation of an atmospheric, three-dimensional object or form is sensitively sought, the edge will be lost where values are similar, and found where they differ, becoming firmer and darker against a light background, and lighter against a dark one. The firmness will vary as observation indicates. The edge will also be mysteriously lost, found, and turned by observing the subtle reflected light near it, particularly when the edge is next to a darker surface.

While in nature the number of planes in any given surface is infinite, the artist arbitrarily limits the number, making his planes larger or smaller as his purposes require. The light and dark areas may be expressed as single planes or may be complicated to any extent the artist desires. By keeping values close together, a larger plane may be composed of many smaller ones and its simplicity of shape be retained.

Illusion is often arbitrarily controlled according to the expressive purposes of the work. Certain planes may be intensified as being more central while others are subdued.

Achievement of atmospheric illusion depends upon relationships of darkness and lightness of various objects or volumes within the whole space. It will be helpful, therefore, first to note the darkest darks and the lightest lights and then proceed from those limits. This process becomes complicated, however, when the value relationships are deliberately altered for the plastic needs of organization, to which illusion is sacrificed. Your darkest, lightest and most intense areas may be associated with the climax of the work, which need not occur in the foreground nearest you.

Since lighting conditions are often complicated, try exercises in which you work outdoors or near a window. Wherever you work, however, control the light so that you have a single source. Your first exercises should keep the plane structure simple. Later you will want to develop illusion further, and then perhaps to manipulate or contradict it.

PLATE 83

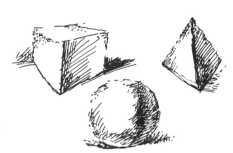

Primary solids

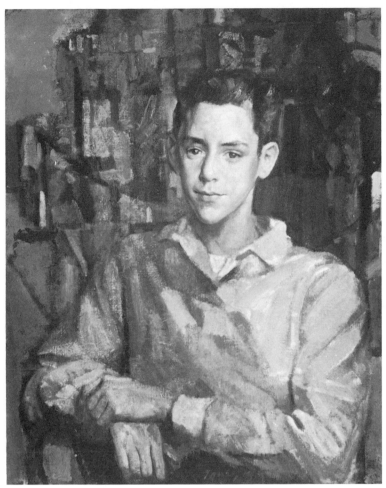

Collection of Dr. and Mrs. Bernard Gluck. Photograph by Juley

PORTRAIT OF A YOUNG MAN

While in nature the number of planes becomes infinite, the artist arbitrarily makes his planes larger and smaller as his purpose indicates.

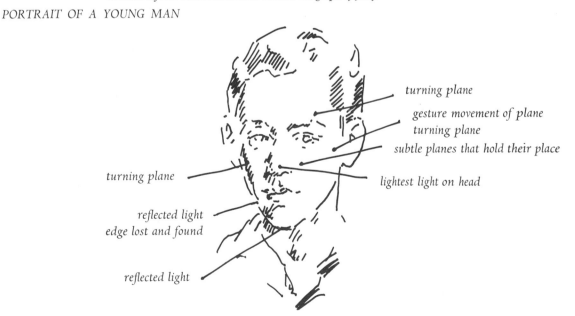

turning plane

gesture movement of plane
turning plane

subtle planes that hold their place

lightest light on head

turning plane

reflected light
edge lost and found

reflected light

PLATE 84

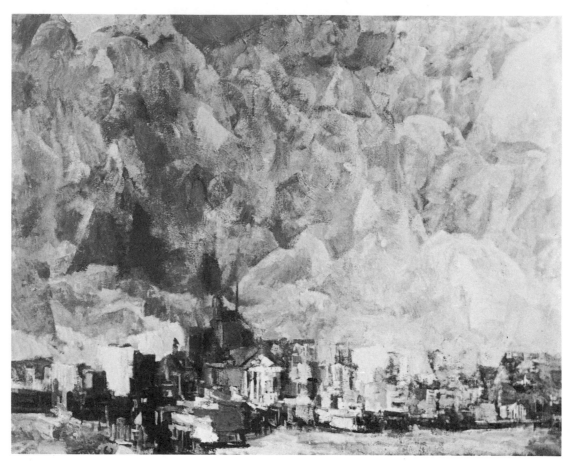

APPROACH TO ST. GEORGE
*Illusion is often arbitrarily controlled for expressive purposes of work. Certain planes
may be intensified while others are subdued.*

*(facing page, top) This canvas is a contrast of yellow-greens and variations of brown
with a counter-idea of blue. Both the blues, yellow-greens, and browns move through
wide range of intensity and grayness as they enter one another in various mixtures;
they counterpoint each other throughout. Main thrust: a dark diagonal at left of
canvas containing progressions of reds to oranges to browns to purple as well as blue,
grays, gray-greens, and smaller intense areas of white and yellow. Strong warm
assertion at left is balanced by smaller repetitions in large yellow-green area at right.
Climax occurs in left center within exploded torsos. Basic triangularity is countered
by circular pattern of blues and whites.*

*(facing page, bottom) Interacting complementary or opposition schemes may be seen here:
red contrasts with the dominant progressions of green, the minor purples contrast
with yellows, and the color is poised against and punctured by whites, grays, and
black. The left climactic area is balanced by a small but intense minor climax at
right of center. The color pattern reinforces and pierces the finger or shaftlike
forms of counterpointing dark and light. The contrasts form a pulse or rhythmic
beat in the work.*

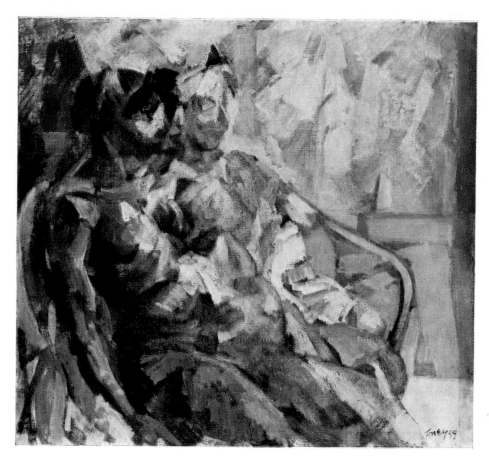

REPEATED FIGURES

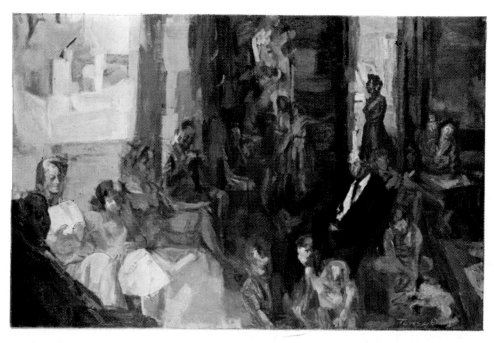

FRIENDS

BLUE PLATE

RED PLATE

BLACK PLATE

YELLOW PLATE

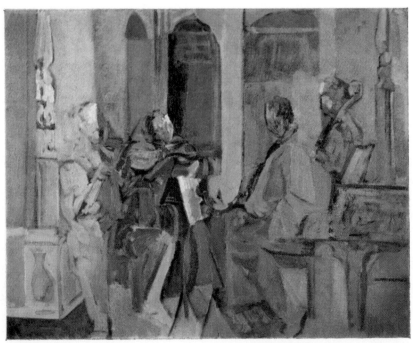

LENOX QUARTET

In the collection of Leonard Brodney

PLATE 85

KATONAH STUDIO VIEW
IN WINTER

ACA Gallery. Photograph by Colten

NORTH WESTCHESTER

Linear perspective as indicated by relative size and horizon line.

(facing page) In the three- or four-color reproduction process, red, yellow, blue, and black plates are superimposed to obtain full range of complexity. The painter can similarly assess each plane as so much red, blue, yellow, and white according to value. Each plane is a gray, more or less intense as hue, depending upon how dominant one of the primaries is. (Color reproductions by Colorgraphic Offset Company)

PLATE 86

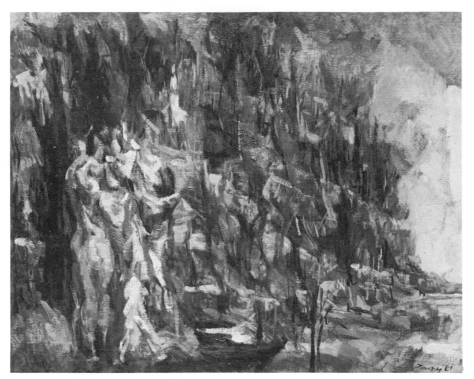

ACA Gallery, Photograph by Colten

GREAT NECK SHORE
Relatively consistent linear perspective.

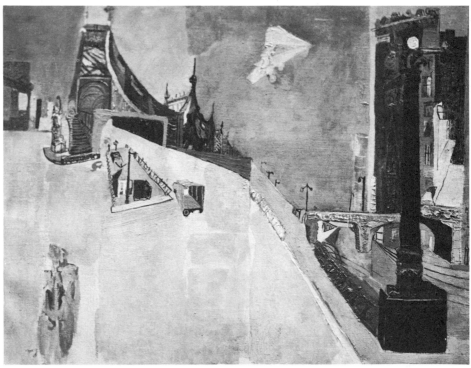

Private Collection

59TH STREET BRIDGE
*Linear perspective exaggerated and manipulated for plastic purposes,
with more than one horizon line.*

Linear Perspective

Linear perspective consists of conventions dealing with the progression of planes to a horizon, or with a system for linear depiction of three dimensions. There are many varieties of perspective, each for a particular purpose. Here we can merely indicate certain helpful information, referring the reader to specialized textbooks to meet more extended needs.

The four perspectives of greatest interest to us are called, simply, one-point, two-point, three-point, and four-point perspective. The "points" in this case are so-called "vanishing points"—points to which the sides of three-dimensional objects could be drawn if extended. These are points of infinity into which space disappears, as when railroad tracks disappear in the distance or humans moving farther away from us become smaller.

The vanishing points exist on our line of vision, also called our eye level or horizon line. This represents one's main eye direction and should be drawn on the upper area of your paper unless you are going to be primarily concerned with objects above the horizon. In actuality, since our line of vision and our position keep changing, so does our reference to objects seen. Perspective thus demands a specific position and eye level, arbitrarily selected.

Perspective can be drawn from nature, imagination or from plans that include floor and elevation measurements. These represent what can be called the given situation, as further modified by one's position or eye level. For the purposes of this discussion the given situation will be an arbitrary one. The important thing is to get an understanding of main principles, and to experiment freely.

The given situations will differ in each of the four perspectives which follow. In one-point perspective you must have a width of line if you are dealing with a flat plane receding into the distance, or a complete shape if it is to be a three-dimensional object. In two-point perspective you begin with a point representing the corner nearest you for the depiction of a flat plane, or a length of line representing the edge of a three-dimensional form. In three-point perspective you begin with only a point again, representing the corner nearest you. In four-point perspective it is a point on the horizon line, since four-point perspective can apply only to forms that overlap the horizon.

ONE-POINT PERSPECTIVE. This is the simplest form of perspective. It includes only one vanishing point, and all side and top lines are parallel.

As an exercise in one-point perspective, draw a horizon line well up on the page. Then place three rectangles, one above, one overlapping, and one below the horizon line (see Plate 87). Establish a point on the horizon to serve as a vanishing point. To that point draw faint lines from each of the corners of the rectangles. Arbitrarily decide where the sides, top, and bottom of the forms should end, and represent those limits with lines parallel to the original shape. Darken the lines of the actual representations and you will note that you have drawn three-dimensional objects as seen above, below, and overlapping your eye level.

PLATE 87

horizon line or eye level VP

One-point perspective

parallel

given or selected shape

VP *horizon line* VP

parallel

Two-point perspective

given or selected line and position

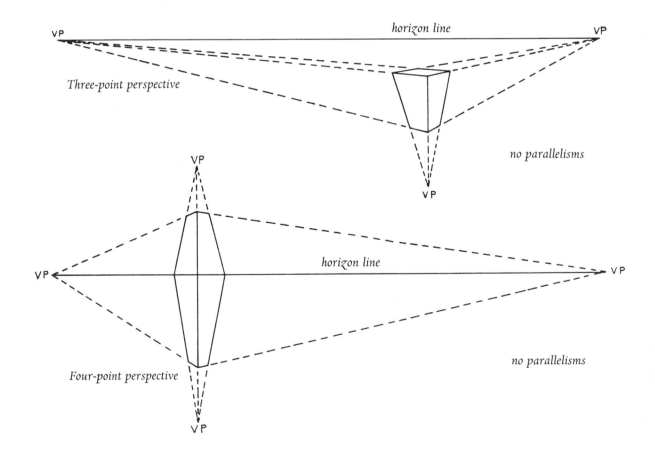

VP *horizon line* VP

Three-point perspective

VP

no parallelisms

VP

VP *horizon line* VP

Four-point perspective

no parallelisms

VP

TWO-POINT PERSPECTIVE. This perspective provides two vanishing points on the horizon line toward which the opposite sides of a given vertical length of line or point recede. In two-point perspective of three-dimensional objects, only vertical lines are parallel; all others get smaller as they approach the horizon.

As an exercise in two-point perspective, draw a horizon line as before, but place two vanishing points upon it at opposing ends and as far apart as possible (see Plate 87). Above or below the horizon, state a vertical length of line, which will become the nearest edge of a three-dimensional object. From each end of the given line draw faint lines to the vanishing points. Arbitrarily decide where the sides should end, and from there draw faint lines to the opposite vanishing point; then draw vertical lines parallel to the given line. Darkening the lines will reveal a three-dimensional rectangular shape.

THREE-POINT PERSPECTIVE. This involves an additional vanishing point, one directly below or above the position of the viewer. Looking down or up adds another eye position and another point to which sides can vanish. Here, all parallelisms are done away with.

As an exercise, establish the two vanishing points on the horizon as before, and add another directly below. Perpendicularly related to the third point, establish an arbitrarily selected point, which represents the nearest corner of the object being drawn. Draw a line from this point to each of three vanishing points. Again determine the widths arbitrarily. From those limits draw lines to the third vanishing point, then to the two others, as in two-point perspective. Similarly, for the height, draw lines to the two vanishing points on the horizon. The effect achieved is that of looking down on a cube, as in pictures of buildings from above (see Plate 87).

FOUR-POINT PERSPECTIVE. This perspective is like three-point except that it adds another vanishing point directly facing the third and applies to objects that overlap the horizon line (see Plate 87). Thus the volume is largest at the horizon line, and both the upper and lower regions, as well as the sides, recede. Three- and four-point perspective most closely correspond to nature's appearance.

One or another of these four types of linear perspective will be inevitably involved in the representation of naturalistic space. While the artist may not wish to draw mechanically, he should nevertheless be aware of the way changes in appearance happen.

Take a cube (or glass) and raise and lower it in front of you. Notice that the rectangle (circle or ellipse) vanishes into a straight line at eye level. Note that you see its top when it is below eye level, and its bottom when above. Place the cube so that it overlaps your eye level; see how the upper lines move down toward your eye level and the lower move up. As you turn the cube, observe that, though the sides are equal, one side becomes smaller and smaller.

Or, as another exercise, look into the mirror and note the changes that

occur as you move your head from left to right and back again. Note the changes in size, the actual disappearance of portions of the features as you turn, and the changes in proportion. Raise your head and lower it, still watching for changes. Drawing naturalistically means drawing these proportions as they appear, not as you know them to be. When the upper part of the head looks large in relation to the lower, that is the way it is drawn.

The place of the observer and his eye level determines in each case the view. As objects move away, they become smaller; as things turn away, they cannot be seen. The farther apart the vanishing points, the slower the speed of vanishing; the narrower, the faster.

Finally, as an exercise, tack paper to a wall; use string for horizon lines and vanishing lines, and thumbtacks to mark the vanishing points. With this arrangement, experiment with the various perspectives we have outlined. You will find such experiments will suggest compositions and broaden your understanding of appearance.

Foreshortening

Foreshortening can be a problem for the beginning painter, and frequently the use of perpendicular or horizontal reference lines will enable him to see where one part is, relative to another—whether it is below it, or to one side, and by how great an amount. Such reference lines will be helpful regardless of what one draws.

In drawing the head, such lines become related to the oval or general head shape. A vertical but curved line, somewhat like a longitude on a globe, can serve as the line of the features, showing their center. Horizontal lines, like latitudes, can serve as place indications of the individual features. Further vertical lines can determine how much of a particular feature is actually seen. Once general position relations are established, draw first those parts nearest you and then the rear, and other limits. The rest must fit between.

Drawing with two main vanishing points means that many of the objects will be parallel to one another. When you wish them to turn or face differently, new vanishing points will be required. The distance between these points should remain the same if the perspective is to remain consistent.

Frequently painters find such single-position perspective too confining. In real life, after all, one is constantly changing his eye level and position, and his view is multiple rather than fixed. Many painters are interested in using this very multiplicity as a source of space ideas.

Other ways of handling space have intrigued painters, such as simply putting objects behind others and higher on the canvas or making important things or figures larger than others. Modern painters have disrupted appearance and then recombined the parts, varying positions analytically, as in cubism, or synthetically as in abstraction. Combined views can also be integrated into a single transformed shape, as in some of Picasso's paintings and drawings.

PLATE 88
Foreshortened body—a contour drawing.

PLATE 89

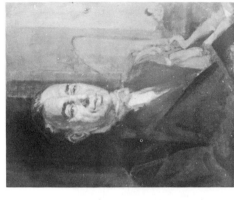

Collection of Maurice Grubin

MAN IN DARK SUIT

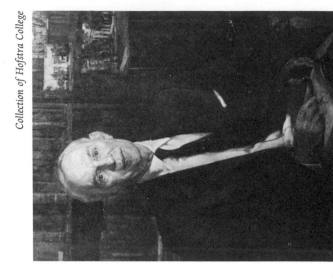

Collection of Hofstra College

DEAN

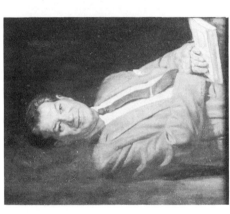

Collection of A. Arthur Smith

MAN

Value relationships in naturalism conform to value range of each object. Here head and figure are lit to reveal plane structure and simplify value relationships to create clearer pattern.

Symmetry and foreshortening of head and body in relatively naturalistic portraiture.

CELESTE

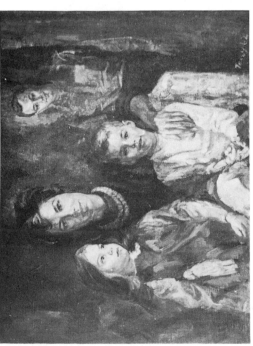

Collection of Mr. and Mrs. Joseph Stuhl

FAMILY

Collection of Celeste Newman

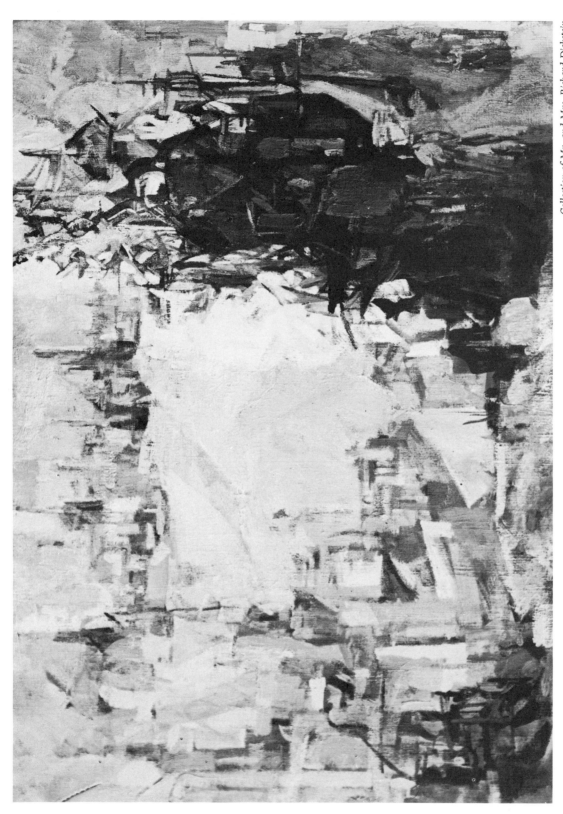

PLATE 90. DOCKS
Contradictions in linear perspective and force relationships of planes can serve to destroy
the illusion of looking out of a window. Thus the plane of the canvas, called a picture
plane, is maintained.

Picture Plane

Since perspective is designed to establish the illusion of distance and volume, its use in a painting tends to destroy the plane of the picture itself. In various periods this tendency has been the aim of painters and there are some today with that goal. If contradictions, however, are introduced into the linear or aerial perspective, a different type of effect occurs: we are reminded that after all we are not looking through glass, and the picture plane begins to be re-established. Such contradictions are simply violations of the way both linear and aerial perspectives work in nature: the rear planes, instead of being made smaller, are perhaps made larger, and so come forward to flatten the surface. Where or how these contradictions are introduced depends on the kinds of space orchestration the artist desires; basically they establish ambivalences so that certain areas of the painting go back and come forward at the same time.

It is this kind of error or negation of perspective that makes the work of some naïve painters so pleasurably decorative. Many painters of today are after a related effect: they are interested in illusionary space but at the same time they want to retain the picture plane; they do not want to fool the eye but prefer to make sure that you know the surface of the painting is a flat surface after all. The opposition of this awareness of flatness and movement in space makes for an exciting contrast that can intensify the expressiveness of the work.

Actual Space

The term "actual space" as used in painting does not refer to three-dimensional relief, though both high and low relief have been interwoven into some kinds of painting. It rather refers to the active physical *force* of a plane moving toward or away from us within any context. Its actuality springs from the concept of light as energy that effects the human organism. The contrasts are revealed to us in variations of light reflected from the light source.

These *force relationships*, as they are called, are related to the relationships of dark and light areas discussed in connection with aerial perspective.* Within the context of a particular canvas there is a movement back and forth which is highly competitive. Those things come forward which are largest, strongest, most intense, sharpest or most distinct, lightest, darkest, or simply different. Those things tend to retreat which are less distinct, less intense, grayer, less dark, less light, smaller or less strong.

Spatially, as in other ways, equalities tend to nullify one another. Thus if everything is very distinct in a painting, something dull and amorphous would stand out and come forward. Contrast functions between similarities as well as between differences. Thus a red contrasts with another red, one being cooler, grayer or warmer or more intense. At the same time, they

* See pp. 136–138.

PLATE 91

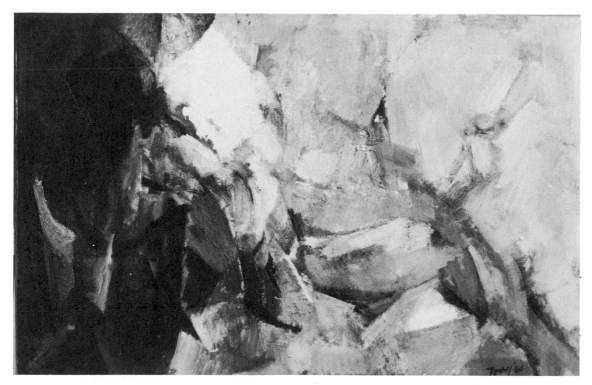

CONTEMPLATION

Collection of Dr. and Mrs. Fred Silverstein

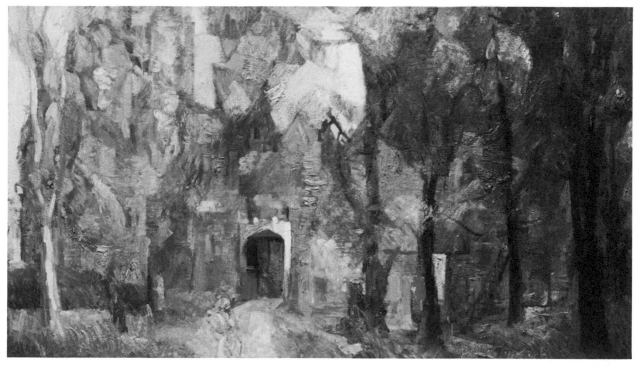

Photograph by Colten

CARRIAGE HOUSE
Planes can function without direct reference to atmosphere or linear perspective.

PLATE 92

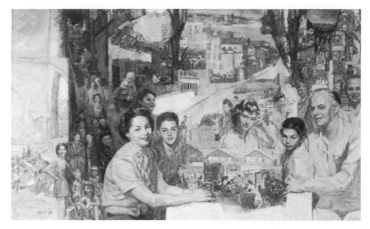

PORTRAIT MURAL

Collection of Dr. and Mrs. Jerome Tobis

Space may be manipulated for ideological or psychological reasons provided contrasts function within plastic scheme.

MONUMENT

will also be relating to other forces, where one quality may be contradicted by others. A gray object that might go back in one context may come forward if it is bounded by black or associated with an intense color. Thus the various planes function not only separately but in conjunction with one another, reinforcing or weakening the other's strength. The assessment of all these forces is performed by our sensibility.

As painting became for many people less and less illusionistic, force relationships became more important. Planes can function without direct reference to aerial or linear perspective.

Modern ideas of space are undoubtedly influenced by the advances of science and technology and communication. Speed, transparency of structure, and severe contrasts have all become important parts of the artist's everyday reality. While distortion of space, furthermore, for psychological purposes was known even before Bosch or Brueghel, many contemporary artists have exploited such changes of size and intensity for psychological projection or symbolism.

A particular artist will use the space ideas that interest him. The space of the classicist tends to be more sharply defined, that of the romantic more mysterious and fluid, that of the naturalist more atmospheric, and that of the realist as necessary for the specific situation. Even the artist who most negates naturalistic space uses it, if only as an implied counterpoint.

Inextricably bound up in the statement of space relationships are both value and color, to which we shall now turn our attention.

Value

As has been indicated, value as a visual element refers to darkness and lightness, its primary characteristics being black, middle gray, and white.

Not only each plane but also each area possesses its distinctive value, just as in nature each thing has its own value range. The range of dark to light on white cloth will be different from that on dark cloth. The range is determined first by the local or actual value that the thing possesses, and further by the nature of the light in the entire situation: the more general the light, the less will be the contrast; the more focused the light within darkness, the more will be the contrast.

In a plastic work, those values which differ radically from their surroundings pull away from them and may destroy the unity of the pattern or of the surface or may become part of interlocking patterns.

A painting will have a value range of its own. It may be a light or dark painting or some variation between light and dark. It may use the whole pigment range or adopt a narrow one. It may be dominated by one value or become a counterpoint of dark and light.

Value relationships help to determine not only space and shape relationships but also the pattern of the painting; indeed, dark and light groupings of various complexity are one of the principal means for the organization of the

PLATE 93

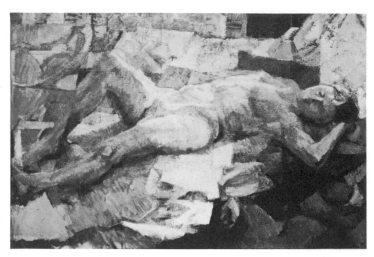

RECLINING NUDE

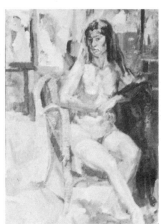

SEATED YOUNG WOMAN

PORTRAIT

Mr. and Mrs. Herzl Emanuel

Value schemes can counterpoint unequal dark and
light areas. Area forming climax will contain
darkest darks and lightest lights.

Private Collection

QUARTET

PLATE 94

Close relationships of value help establish value patterns.

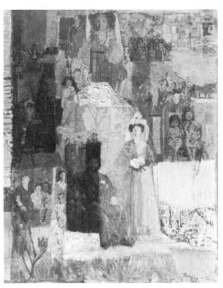

Collection of Mr. and Mrs. Shnorer

FAMILY TREE

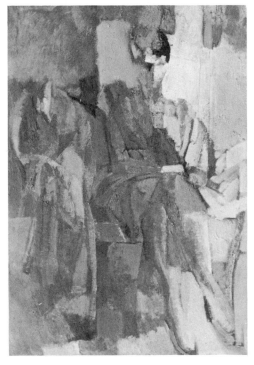

READING TEEN-AGER

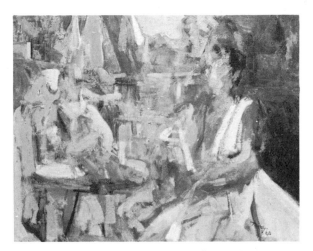

BY THE POOL *Collection of Sylvia Toney*

Value ranges can differ greatly in paintings and drawings.

PUBLIC BUILDING

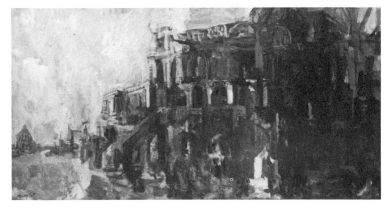

canvas. There, patterns are created through similarity of value. The value pattern structure will have its darkest darks as a pattern within the dark areas and its lightest lights as a pattern within the light areas. Patterns can take on almost endless variations of shape, from simple to complex; but the variations revolve about pivotal geometric shapes, parallelism, or some combination of these.

Obtaining the desired value is sometimes difficult. Accept the fact that you will need a number of trials; these will help you if you use them as points of departure. Evaluate their relative darkness or lightness and work accordingly. If you want to mix a light color, start out with white and add a little of the desired colors. If a dark color is desired, leave out the white until last, and then modify as necessary.

In general, establish the value relationships of your larger planes first; they will help you to keep the superimposed or related values similar. It is difficult to see values in the larger context, since the student too often looks at the part rather than the whole. A dark area will grow lighter and a light area darker as you look into it. Only by reference to the whole, to similar values, and to extremes can you see its actual value.

An emphasis upon value relationships is typical of tonal painting, where color is seen more as a variation of gray or as earth colors, with little use of primaries. More explicit use of primaries results in prismatic painting. In either case, every value has its color components even as each color exists as a value.

CHAPTER VIII
ELEMENTS: COLOR AND TEXTURE

Color

In an earlier section I indicated which pigments the student might prefer for his palette. Now let us look at color itself, the essential characteristic of painting.

Primary colors are, of course, red, yellow, and blue, which become, in pigment (and through the necessary warm and cold variations) the basis for secondary and other mixtures. Purple is a mixture of purplish blue (ultramarine) and purplish red (alizarin crimson). Orange is orangish yellow, a mixture of a deep or medium yellow and a warm cadmium red light. Green is a combination of cadmium yellow light and cool phthalocyanine blue. These colors—purple, orange, and green—are called secondary colors, and a tertiary level, as we shall see in the next section, is also to be found. The primary not used in forming a secondary color is known as its complement. Equal quantities of the primaries, or equal quantities of a secondary and its complement, create neutral gray.

In nature, because of the effects of atmosphere, light, and space, all color is found in an impure state. Whatever the brilliance of appearance of any local color, some mixture of all the primaries will be found to be present. The color-reproduction process, which mechanically separates the primaries and then superimposes the separations, is an illustration of this. Once the painter accustoms himself to this simple concept through comparison of one color with another, he will be able to assess the relative amounts of red, yellow, or blue in any particular area.

157

It was this concept that the impressionists, concerned with the problem of light, attempted to make explicit by separating the components into dots or dashes of primary colors which, superimposed and placed side by side, were to synthesize at a distance into the local color. While they were not consistent in their approach, they at least succeeded in drawing attention to the struggle of color contrasts, their vibration and power, both plastically and psychologically.

Inevitably, in the search for light the analytical approach tended to negate the local color it had originally hoped to suggest. When the assessments of relative amounts in particular areas were in error, local color was partially destroyed as everything became red, yellow, and blue, or a similar kind of prismatic gray. The stress on spots of color also began to destroy the edge as line, to negate shape, and to obscure the illusion of volume. Reaction to these weaknesses, as well as to the more positive discoveries of the impressionists, helped to engender the series of explosions that in this century exposed the varying levels of the painting structure and burst them into fragments, each of them to become a personal direction.

Color exploration turned into feasts of opulence on the one side and negative reaction on the other—into either richness or asceticism. It avidly investigated the psychological, structural, and illusionistic possibilities of color. Everywhere, the emphasis on prismatic relationships and even their negation, as black, white, or gray, served to point up the central role of the primary colors, the power of their contradiction.

Any color theory for the painter must now base itself upon this fact, that every color is made up of but three primary components. In pigment, the three color variables become four as white is added, and then at least four more, as warm and cold variations of the primaries are required. But the relationships of the basic three components will open up the whole range of expressive color.

Illusionistic Color

After the analytic stress of impressionism, all subsequent naturalism was inevitably transformed. Illusion created after that time did not have to be explicitly prismatic but had to take the prism as its base. Today this influence comes not from impressionism itself but as it was developed by the post-impressionism of Cézanne, by the Fauves, and modified by ashcan, regionalist, and social-realist schools.

Profound naturalism originates in a full consciousness of color changes in each plane and some illusion of continuous difference of color and value. This movement of planes must take into account the counterpoint of cold and warm colors, of primaries and their complements, and of color and its negation.

Since each plane is a different combination of primaries, each embodies some color contradiction. The primary opposition is the root of all others; any complex color plane or group of planes can therefore be separated into

relative quantities of primary components. Each will be found to be dominated by one or two primaries, or else possess relatively equal oppositions of all three. One can see this best by comparing a complex color with the primaries or secondaries or with another complex color.

In atmospheric color, as we have suggested in our discussion of perspective, relative grayness increases as the distance or thickness of the layer of atmosphere increases. The less the thickness (or the nearer the color to the position of the viewer and the source of light), the more intense, more pure, more sharp, and lighter or darker the color will be.

In any expression of the illusion of space through color, therefore, the stronger, larger, and more intense colors will come forward and the weaker will retreat. Each has an absolute position within any particular context, though the artist's assessment is not absolute but determined subjectively.

In this contest of forces color does not work alone but works in conjunction with such other associated elements as line, value, and so on. Where a color itself might retreat because of its intrinsic local quality, it might come forward when associated with sharpness or darkness of line, when juxtaposed to stronger color, or when influenced by size and clarity of shape.

Against a medium neutral situation, equal amounts of a medium red will come forward as compared to a medium yellow, which remains unchanged, or a medium blue, which will retreat. However, this contest of oppositions is affected by, among other factors, quantity and value. In a canvas predominantly red, reds will tend to negate one another and colors that are different come forward—particularly the complement of red, green. In any situation dominated by prismatic color, on the other hand, gray will come forward. Thus in any color situation, as in any plastic complex, the color that is different will come forward, while equalities of any color will tend to negate one another.

Colors act as competitive forces, and as such intensify and bring each other into being. Thus the highlights on an orange will tend toward the opposite of orange, a very light gray-blue. While all primaries and secondaries oppose one another, the strongest oppositions are those of complements. Such oppositions may exist at various levels.

The simplest level is that of a primary (red) and a secondary, its complement (green), composed of the remaining two primaries (yellow and blue). All primaries are present in every complementary situation, and every primary is by definition the complement of the remaining two primaries mixed together.

Such oppositions are stronger than those between two primaries or those in which one color is repeated. When only two primaries are involved, as in the opposition of blue against yellow, the opposition is somewhat weakened. Still weaker is the opposition of green against yellow, where both possess the common quality of yellow. This association weakens the contrast and turns it into a color idea dominated by yellow. The extent of negation of contrast is relative to the quantity of the binding color.

At the tertiary level, complements are found in a manner similar to those of the first level. Thus the complement of red-purple is made up of the complements of red (green) and of purple (yellow), giving us yellow-green. The complement of blue-purple becomes yellow-orange; that of blue-green, red-orange, and so on.

Our own awareness of color is always in terms of light. Direct light is painful to the eyes and we avoid looking at it, but objects are revealed to us as they absorb and reflect light. We need not go into the wavelength or corpuscular characteristics of light rays, or even into the fact that differing wave lengths (in height or complexity) determine the intensity and saturation of hue. We should, nevertheless, be aware of the physical nature of this contact, of the electronic rays, moving at vast speeds, which stimulate the rods and cones of our visual structure and, through them, our nervous and other systems.

The more light an object is receiving, the relatively more intense will be the local colors and their oppositions. The less light being received, the less intense or grayer will be the oppositions. Spatial qualities are most fully revealed when there is one main source of light; the resulting dark and light and more or less intense hues show the nature of the object. If all planes are equally lighted, the only perceptible visible differences are those of shape and local color. As has been indicated in our discussion of naturalistic space, if a volume is lighted from one source those planes nearest the viewer and the source of light will tend to be most intense both in the dark and light areas, and as the planes move away they will become grayer and be modified by reflected light and color.

Local color, or the actual color of an object, its particular over-all complex of red, yellow, and blue, is also modified by light and dark and resulting changes in hue, as well as by color reflection from other objects.

Warmth or coolness of light (its tendency to move toward orange in the case of warmth, or toward blue-green in the case of coolness) also affects color. A warm light emphasizes the yellower aspects and the complement purple. While actual light situations are more complex, the above rule can be used as a comparative principle.

Artists painting indoors at night try to get a combination of warm and cold light that will help them maintain stable mixtures. If one paints under a yellow light, for example, while everything else will appear to be more yellow, the pure yellow pigment itself cannot, and one may therefore be influenced into the use of more yellow than necessary.

In addition, the same color, stated on different parts of the canvas will appear different if given contrasting contexts. Thus the same red will look less red against a different red, and more red against blue or green, and will look different from the way it does against white or yellow. Opposites tend to cause greater tension.

Within any local-color situation, it is possible to have wide contrasts provided the planes have suitable transitions, are not too large, or are part of an

over-all texture of contrasts. Just as any particular local value has its own value range, so does each local color have its own color range of variation of hue. Beyond this range, if the plane of color is sufficiently different or large enough, disruption of the local color will occur.

This type of rupture destroys naturalism but it may heighten psychological tension. Thus the naturalist must find ways of explicit and implicit use of color contradictions while still maintaining the local color. Cézanne indicated the possibility of using juxtaposed contrasting planes, a method that can become extremely subtle as the planes become increasingly small. The use of glazes, dry brush, and delicate hatchings, as well as the dots of impressionism, are all methods of breaking up yet maintaining continuity of surface and local color.

While each of the two modes of working—part-to-part or working in relation to the whole—can result in naturalism, the wholistic is the more efficient path of accuracy. As previously discussed, one should experiment with the rapid statement of the largest color contrasts, modifying them freshly and boldly until they generally correspond, before proceeding to the smaller planes of color.

In summary, then, keep the three variables in mind, and no matter how gray the color, compare it with another and see how much warmer or cooler it might be. If you wish to mix a light color, begin with white. If you are going to experiment with impressionism, prepare varying values of each color before you begin. An underpainting of value relationships will also be helpful toward keeping the pattern clear. Try to realize the local color even as you break it up; the local color comes from a quantitative situation of simply having more of a particular color or two. Mix your color thoroughly and often; each time you pick up color make sure it is at least a little different from before. Arbitrarily counterpoint warm and cool variations even if you cannot see them; gradually you will learn to do so, to distinguish the subtle variations through comparison. Use similar hues and particularly the primaries and secondaries as comparative references. Finally, learn to move your eye over the whole canvas. If the limits of the color situation are stated, the rest will find their place more easily.

Plastic Color

While naturalistic color tends to destroy the picture plane, moving as it does between a foreground and deep space, plastic color, by using the force relationships of naturalistic color contrast more explicitly, attempts to maintain the picture plane. By ''plastic'' is meant any organization that stresses the orchestration of the various color impacts for structural reasons rather than for naturalistic or emotional expression. Plastic or personal color organization thus replaces correspondence to nature as the main purpose of the work. Much that has been said about illusionistic color applies to plastic color, but the latter is manipulated more arbitrarily for varying purposes.

In a plastic situation, color moves in terms of patterns, thematic sequences,

spatial contrasts that draw the eye through and around the canvas in an organized color experience that culminates in a climax where the color is more intense or most brilliant. Color is arbitrarily distributed and its determination is judged in terms of its organizational role.

More will be said later about this structural role, but here we should remind ourselves of the main possibilities of color themes—that the three primaries form the base of color ideas, just as they determine any particular color situation, and that any color scheme is dominated by one or two of the primaries or else is a relatively equal counterpoint. Those color schemes that employ all tints, shades, and tones of a particular color, of closely related colors, or of colors that are harmonized by the intrusion of a specific color are called *dominated schemes*. Those in which contrasting colors are stated relatively equally are called *opposition schemes*. Actual equality of tension or of quantity, of course, prevents movement and is undesirable.

In dominated schemes, all three of the primaries will be used to provide contrast; basically, however, the scheme is one that is dominated by one or two of the primaries, with varying amounts of white. One of the primaries or secondaries is varied by relative amounts of the remaining primaries. The latter can be called a contradiction within the main idea since it is an intrusion of an opposing color.

In opposition schemes, two or more of the primaries or secondaries counterpoint one another throughout. They progress, with variation, by embodying the remaining colors. Thus, in a red and green idea, the reds progress as they embody relative amounts of green and white, and the greens move as they embody white and some of the reds. This variation is more extensive than first appears, since it also includes varying intensity, value as well as relative grayness. Each color, moreover, has its own range, which adds further possibilities; since green, for example, is itself a composite of varying amounts of yellow and blue, it has its own extensive range which enlarges the possibilities of both progressions.

Each color idea, on the other hand, has limits beyond which the color is no longer in that scheme; thus the range of the green we considered is so large as to move into other color ideas as it approaches either blue or yellow. Enough redness or greenness must be evident, in our hypothetical red and green idea, to maintain consistency. Variation is thus a *quantitative* relationship which, if intensified beyond a certain point, becomes a *qualitative* one, in which, for example, red becomes orange or yellow-orange, or green becomes blue or yellow or both make neutral gray.

Both types of color scheme embody their opposition, not only within themselves as variation or implicitly, but also as they are opposed by subordinate themes and explicit opposition ideas. Thus, the above red and green main theme might have a subordinate theme of blue variations and an opposition or counter theme of grayness that moves from white to black. In a scheme dominated by blue, there might be a counter theme of orange and a subordinate idea of gray. In either case, both main and lesser roles are deter-

mined both quantitatively and qualitatively. There will be *more* of a main idea than of either of the others, and the color of each will be different enough so as not to be confused.

Assessment of such quantity and quality is through impact upon our sensibilities; it is a subjective judgment of an objective situation. The relationships are absolute, but our determination of them is relative. Our awareness of this impact constantly changes as it is enriched by experience, either through painting (directly making choices), or indirectly, through the influence of other paintings and other visual experiences. Judgment of quality is further aided by reference to the primaries as points of comparison.

Since color ideas often become too complex and since one strong idea may negate another and cause confusion, André Lhote has suggested that in any particular painting only one of the primaries should be brought to full intensity, and then contrasted with black, white, or gray. Fundamentally, the student or artist should base himself on his own reactions. Color discoveries are still being made, and the sooner that you consciously feel the relationships, the sooner you will be making your own. The countless variations and contrasts involved in any orchestration of color need a heightened sensory awareness rather than reliance on mechanical formulas.

The student should explore simple exercises as well as total problems. Try putting two colors together that are resonant or particularly satisfying to you. Give yourself many trials so as to extend your choices.

Colors that are close or related in hue tend to be seen in terms of one another and so form a pattern in the work. As in a value pattern, this related aspect is used as conscious means of organizing the movement of the eye through the canvas and of holding the work together. Color and value patterns sometimes reinforce and sometimes oppose each other. As with value patterns, the color pattern may take various shapes related to the geometric possibilities of shape organization, as previously discussed.

Color-pattern exercises are an important means for the student to learn to control and experiment with color ideas. Make rapid contour drawings upon which you establish various value patterns. After this layer is dry, superimpose a color idea, including main, minor, and opposition ideas. Often you will find that simply stating a main idea will bring, through misjudgment, minor and opposition ideas into being.

Color sketches are important to help clarify and elaborate your choices. Montage often becomes a short cut to finding exciting ideas, and other experiments will further extend your experience. Most important are those which require your actual handling of pigment. The beginner usually picks up too much at one time with his brush or palette knife and finds it difficult to mix the hue desired. Try developing the habit of dropping off a little pigment each time that you reach for a color, picking it up again later as necessary. Do not let the quantity being mixed get too large. If you still do not get the hue desired, take just a portion to change. Since control is a matter of experience, you should paint as often as you can.

Overstatement is a problem, not only when you are mixing colors, but when you are making changes on the canvas. Once your painting is set, make your adjustments just as boldly as before but with sensitivity, even tenderness. Planes may need to become smaller, and dry brush and glazes may be useful for subtle changes.

Psychological Components

Psychological tests indicate that most people think they like certain colors best. Blue is a favorite for many, with red, green, purple, orange, and yellow following in order. Red and red-orange are considered exciting, blue and blue-purple peaceful, green and yellow-green tranquil, and yellow cheerful. A person "sees red," experiences "red-letter days," encounters "red tape," is "in the red," and so on.

All plastic use of color inevitably embodies such psychological associations and possibly symbolic meanings as well. The naturalist may feel unconcerned with psychology; but the classicist, the romantic, and the realist more or less consciously employ color in psychological ways. Van Gogh's letters made specific reference to the psychological meaning of colors he employed.

Thus color is sometimes felt in terms of other senses. Newton saw the sound of C as red, D as orange, E as yellow, F as green, G as blue, A as indigo, and B as violet. Musicians such as Liszt, Beethoven, Schubert, and Wagner referred to color associations of sound.

Taste also develops associations, as in so-called sour and sweet colors. Bright red, orange, soft yellow, and clear green seem appetizing to many, yellow-green far less so. Similarly, some of the pale pinks, lavenders, yellows, and greens are considered by many people to smell best. Red seems hot, orange and yellow warm, green cool, and blue cold. Orange and yellow seem dry, and blue wet.

Such color associations stem from direct or culturally inherited experience; we associate certain colors with certain experiences, and their later use recalls the experience to our mind. Color symbolisms in turn are derived from such associations, and may be either personal or social, the social becoming personal as it is given specific individual content, the personal becoming social as others learn of it and employ it for communication.

Color was, not surprisingly, a part of early superstitions, and was and is used symbolically in customs, religion, heraldry, for the seasons, and so on. For the ancient Israelites blue was the symbol of love, fidelity, and purity; in religion it stood for heaven or truth. Green is the symbol of nature and purple of sorrow. In heraldry, red means bravery and courage, while the red cross of today stands for love and mercy. To the U.S. Coast Guard white is the symbol for fair weather, blue for rain or snow. Such symbolic use of color is endless and often contradictory, to be specifically understood only in particular contexts. While there may be some associations that are universal, most are culturally learned and subject to change, proliferation, and ambiguity.

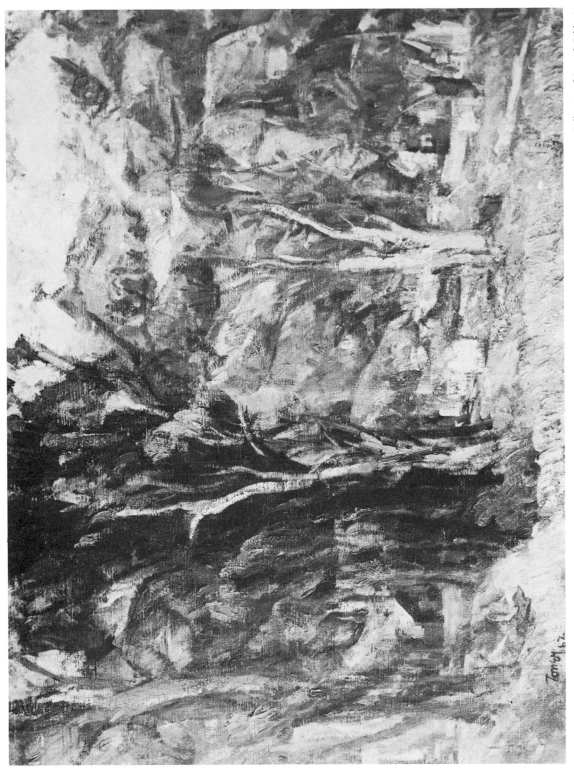

PLATE 95. COUNTRYSIDE
Three types of texture—actual, illusionistic, and visual—are extremely important in contemporary work.

At certain periods of the past, as in Gothic times, artists had to work within quite precise symbolic color vocabularies. Today most painters prefer not to develop any such clear correspondence. Color associations and symbolism enter the painting as resources, to be used or not, like any other aspect of painting. Certain types of problems may require extensive research; others may rely on the unconscious. Both associational projection and explicit and implicit symbolism become tools for self-discovery as well as for social discovery and communication.

In many kinds of abstraction, mood is determined by the quality of color and thus is of great importance to the work. In such paintings associations will be projected whether they are intended or not. Even naturalistic work will have its psychological color components.

The student should experiment with color, allowing free play for its use as it gives him pleasure or seems meaningful. Try to make explicit use of color symbolism whether it is socially dictated or personal. Explore different schemes to discern the variations in mood that the colors suggest. Can you set up in color the feeling of a musical work, or that of any other sensory situation?

Color is the painter's most important element. By creatively acting and reacting in color, he searches for a new and more meaningful color experience.

Texture

The element of texture has become extremely important in contemporary work. All kinds of experiments have illustrated contrasted textures and their progressions, and montage and collage have further extended textural range.

Basically, texture has a threefold role in painting. There is the *actual texture* of the materials employed, whether these are paint in its various forms or paint adulterated or amplified by other materials. Secondly, there is the *illusion of texture*, as when paint creates the illusion of the texture of hair, skin, and so on. Finally, there is what I call *visual texture*, or texture of the dark and light configuration.

Each of these roles includes similar extremes of roughness and smoothness as well as having a medium texture. Any other texture is some combination of these.

ACTUAL TEXTURE. In some instances actual texture has become almost high relief, as in some collages which add sizable objects to the work. The use of sand and other materials has had much popularity. At present, the use of plaster or cement is giving painting an even more overt sculptural orientation. Many painters have found a power and zest in piling their pigments high over the canvas.

Artists of all times, however, have been sensitive to the actual texture of their pigment on the canvas. It plays a specific role on that level, whether

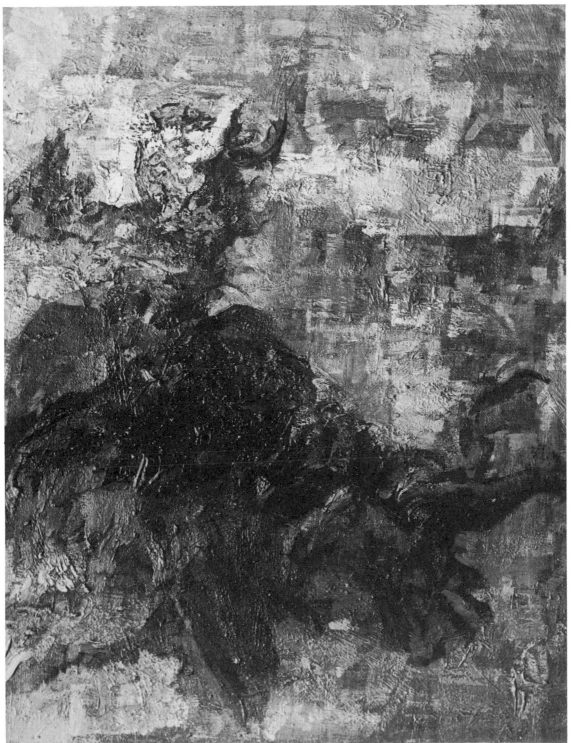

PLATE 96. BIRD

The actual texture of the paint surface becomes an element in the orchestration of the canvas.

PLATE 97

Checkerboard-like contrast in value creates a rough visual texture; closeness of value forms a smoother texture. Progressions of kinds of related roughness and smoothness form thematic variations that help to articulate and unify the work.

BANK *Private Collection*

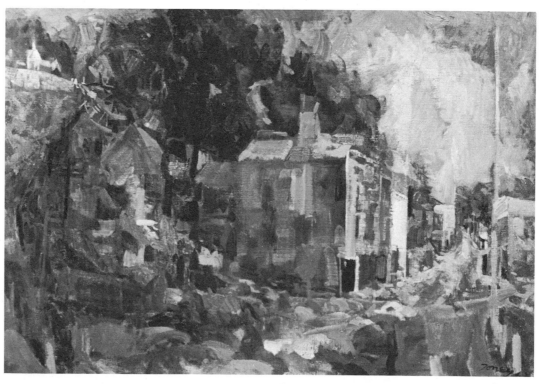

PURPLE MOUNT KISCO

Collection of Dr. Samuel J. Penchansky. Photographs by Colten

within a narrow range of smoothness or roughness or within the wider range of contrasted progressions.

THE ILLUSION OF TEXTURE. Naturalism depends much upon the illusion of texture. The feeling of a particular surface quality is achieved through the superimposition of layer upon layer of complexity, beginning with the general and working gradually toward the finer detail, so that the detail works within the general and does not pull away from its context. The detail must hold its place.

The illusion of texture may be arranged also so as to function as visual texture, with aspects or details of the illusion being stressed to play a more overt visual-textural role.

VISUAL TEXTURE. Contrasting patterns, large or small, create visual texture. Here textural progressions and contrasts work as color does to move the eye through the work. Thus, visual-textural progressions are an important means of organization.

Some painters have attempted to have all three aspects of texture reinforcing one another, so that actual, illusionistic, and visual textures work together, at once describing and acting plastically. Others have used them in contradictory ways, in at least relative opposition.

All three levels of texture are organized as the other elements are. That is, the work may be dominated by one texture, or be a counterpoint of contrasts.

CHAPTER IX
THE ANATOMY OF ORGANIZATION

Introduction

The basis of all organization in art is plastic generalization. Visual generalizations, derived from analytical comparison, are concerned with the similarities and differences revealed in our visual resources; and the recognition and assessment of these enable the artist to control the work toward representational achievement or creative adventure.

The impressionists, as we have seen, exposed the inner oppositions within color; Cézanne, the geometric character or content of natural forms; Van Gogh, the psychological content of color and the geometry of shape and pattern. The cubists' stress upon the independence of continuity of movement and the similarity of direction from any particular position or view exposed what might be called the geometry of transformation, a geometry that in the work of the purists becomes precise.

This analytical heritage can be fought against or used to our own advantage. Nature, art, and society, however, are complex; we need every tool that will expose their contradictions and help us to assess them.

In art, generalizations of similarities become *themes*, and contrasts or oppositions within them become *variations* that progress the theme. Other generalizations become *minor themes*, which in turn have their variations; still others may form *counterthemes*. This dynamic structure of main, minor, and opposing themes provides the substance of the organic oneness of the work.

Such a view indicates an almost scientific weighing of forces, a mechanical observation of sameness and contrast. In reality, the artist's choice is far

more subjective, based upon his tangled inner and outer conflicts. Nevertheless, the analysis is a beginning, a base upon which decision can function. This decision, in turn, is aided by our ability to recognize solution patterns, often occurring in a flash of insight.

Insight

All that happens to a person, the totality of his experience, forms a matrix— his particularity. This matrix provides the inner limits of opportunity, or order and disorder in the movement of contradictions. The particular relationships found in it determine which problems the artist will tackle and what he will recognize as being pertinent to them. Often significant patterns can pass unnoticed and absurd ones acquire the force of a flash of insight. The artist cannot see solutions for which his internal structure is unprepared.

Once seized with a problem, the artist's inner structure moves in terms of it. Sequences of variables occur, patterns succeed one another until finally one is set up that, seeming most significant to the artist, spurts into consciousness. The accumulation of many changes in a struggle of opposing ideas culminates in a seeming resolution as the pattern is judged as right. Actual test in reality—in the painting itself and in the consciousness and experience of others—further determines the validity of the artist's judgment. Often the insight proves false and the process has to continue. The most satisfying resolution remains relative, its equilibrium only temporary as new levels of contradiction force new solutions, problems, or paintings into being.

So long as confusion or equal opposing possibilities remain, the artist's judgment will involve anguish. It is during the long, frustrating period of resolving this equality that the painter will require the utmost patience and belief in himself. Sooner or later the synthesis will occur and be recognized.

The drawing or painting provides a visible record of this process; fortunately, the work exists all at once in a form that allows time for looking, for searching out its many contrasts. Thought is like music in that only the changing present idea or sound exists; but a painting, a physical entity, presents a more permanent totality of forces to assess. This exposure to successive visual patterns allows sensibility as well as thought to function toward the desired judgment.

This process of qualitative transformation occurs not only in the realm of ideas or physical representation but also in the artist's development of skills. In each there are the same plateaus of small changes of imperceptible development, followed by the same sudden bursts into new levels of competence; there is the same anguish as the plateau seems at times to extend endlessly. Through past experience of success the artist learns to become confident and patient, though still not without anxiety. The student needs to become aware of this mechanism and trust it in himself.

Finally, the three interacting processes of organization, discovery, and judgment must evolve a whole concrete work, organically one. As an object the

work is now separate from the artist yet tied through him to all humanity on all the levels of meaning it possesses. As art it cannot function without a human being. With each person it will communicate according to his own level of awareness.

It is this physical entity that becomes the painting or drawing which now concerns us, the structure of the object, the forces it contains, the particularity of the plastic language. In our discussion of the creative process I have called this step objectification. It occurs, not as a last step, but simultaneously with the period of conception.

Thematic Structure

It should be evident by now that the visual elements of art are within each other and largely inseparable. While one or another may be stressed at any time, all of necessity coexist at every moment. Line establishes shapes which become planes as contrasts of values, colors, and texture are stated. Any area has at once a value, color, texture, shape, and line as outline or contour.

The organization of these elements requires their *orchestration*. While drawing dismisses color, and contour drawing may be limited to line and shape, the elements generally enter and affect one another, providing variation and contrast. Progressions of color are progressions of value and shape that move in particular directions and create or possess certain textural contrasts. To progress through a work, a shape needs to contain color and value contrast, change in size, direction, and contour, as well as spatial position and texture.

Organization is the synthesis as we have seen, of main, minor, and opposition themes, each of which progresses to a relative climax and equilibrium. The *main theme* becomes the *main contradiction* which determines the *subordinate* and *opposition* contradictions. The climax of the main idea dominates the others.

The progressions of the themes employ the association of like qualities in movements of contrasting pattern and the relatively regular repetition of movement or any visual aspect that creates a binding rhythm. The harmony imposed by the main contradiction is pointed up by surprises and dissonances. The climaxes, main and minor, are the points of intensity or of severest contrast. Balance, whether symmetrical or asymmetrical, establishes an equilibrium of the contesting forces.

Unity is established through thematic progression, domination, rhythm, pattern, and balance; contrast is established through variation, opposition, dissonance, and climaxes.

While each of the elements serves to establish contrast within any progression, each element must have a relative organization of its own. Thus there will be linear, shape, value, spatial, color, and textural themes each of which progresses, has main, minor, and opposition themes, reaches a climax, and so on. If you look at the separate plates of a reproduction of a good painting—

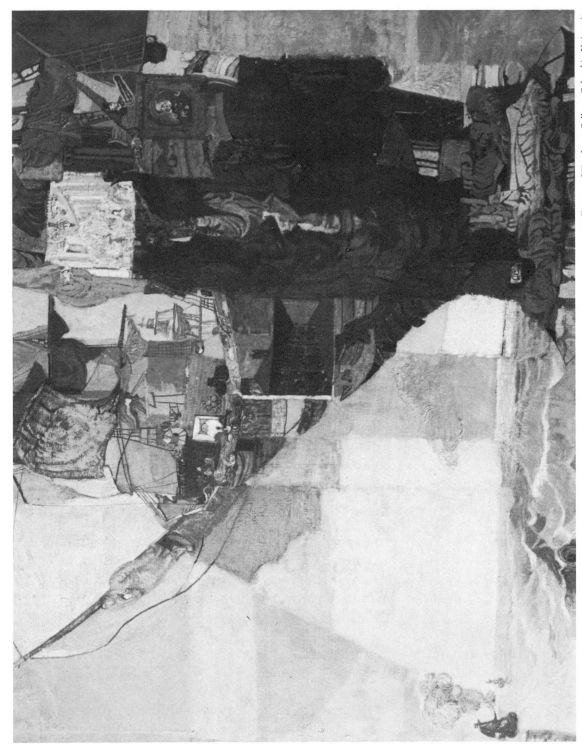

PLATE 98. SLAVE SHIP

Patterns of like values or color can hold together a rich amalgam of symbolic images and allow them to function as part of a plastic whole.

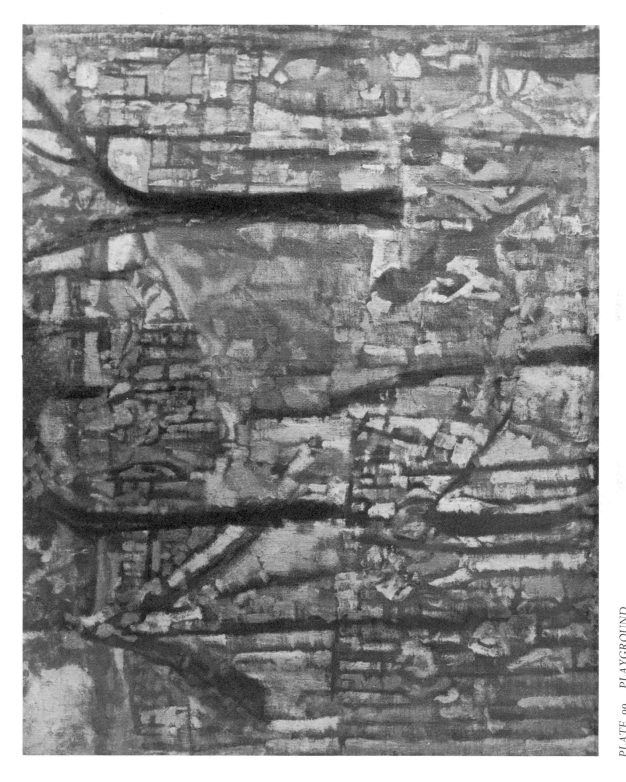

PLATE 99. PLAYGROUND
Strong repetition of vertical thrusts becomes a rhythmic beat uniting the work.

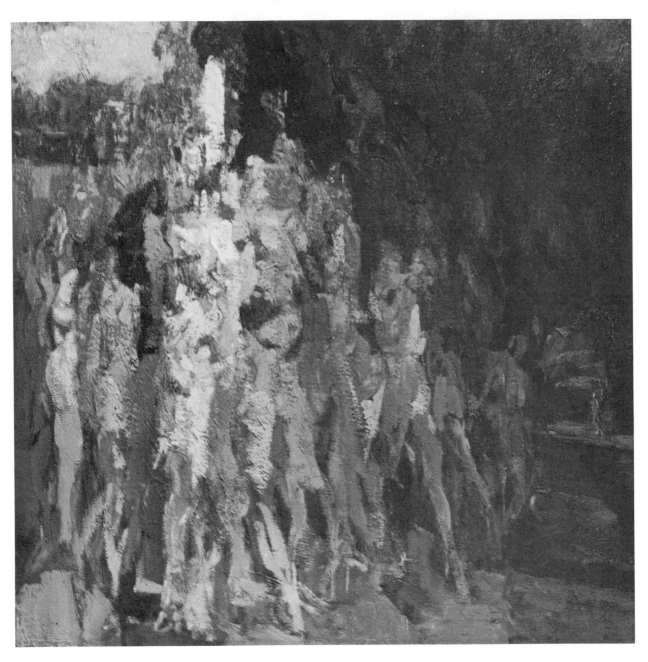

PLATE 100. BATHERS AT BEAR MOUNTAIN
The climax of the work becomes the shaft of light, left of center, reinforced by darkest
dark and most intense color.

PLATE 101

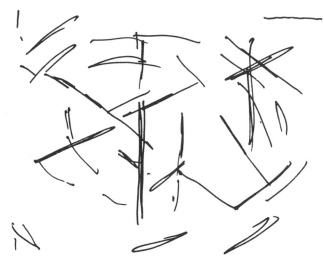

Symmetrical balance: center is fulcrum of spokes of wheel-like pattern. Symmetry is destroyed by weighted left-hand corner.

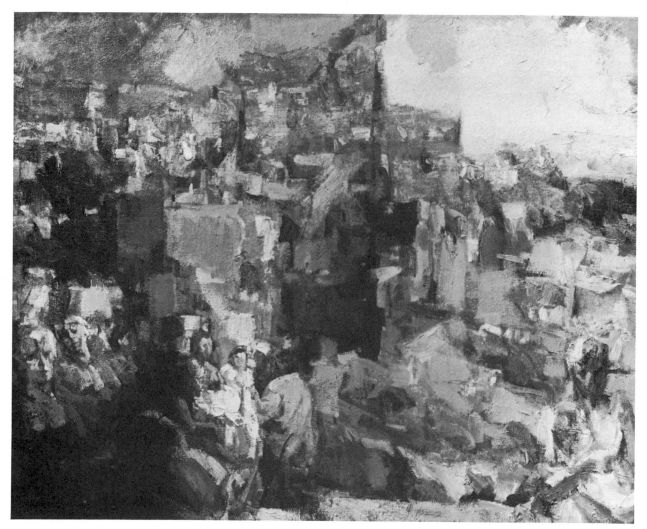

PICNIC OVERLOOKING AMSTERDAM

Collection of Dr. and Mrs. Louis J. Crane

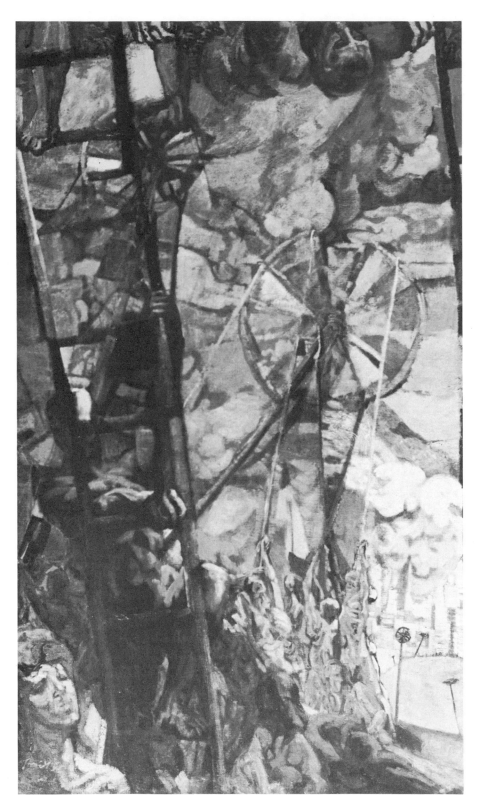

PLATE 102. COUNTER-REFORMATION
Asymmetrical balance: main weight at left is balanced by few darks that intrude at upper right.

the red, yellow, or blue plates—you notice that each becomes a complete drawing in itself, different from the others but possessing a completeness of organization. In the same way, if you examine a good painting, element by element, you will find that each element has a main assertion, minor ones, and contrasting ones. Each element works as and of itself, even as it makes possible the others. The drawing can be examined apart from the color ideas: it must hold up as a drawing. Value, spatial, and textural ideas can be similarly appreciated.

The principal device for orchestrating such elements is that of *pattern*, which, whether as color or value, binds line, space, shape, and texture to its will. Pattern possesses shape and embodies shape contradictions within its overlying similarity of value or color and as it contrasts with other patterns. Patterns cannot exist singly; they counterpoint one another—a dark pattern against light, a green against red, and so on. The pattern will move in a particular direction, creating implicit and explicit shape relationships. It acts also as a sequence of planes that progress as spatial contradictions. It asserts the picture plane even as it moves back and forth from it. Visual-textural progressions become an integral part of its movement in the same way that value and color contrasts do.

An important aspect of pattern is *rhythm*. This relatively regular repetition of shape, linear direction, color, spatial position, value, or texture helps to order the progression of the work as a totality—to order the main assertions relative to the lesser ones.

Finally, the *main climax* becomes a culmination of the orchestration of the elements. All the progressions serve to reinforce it. It is created out of their combined efforts as each climax occurs in relatively the same general area of the work or at least contributes to it.

Another means of resolving the various levels of contradiction is that of achieving equilibrium through some form of *balance*, whether it be symmetrical and asymmetrical.

Symmetrical balance is that between tensions which exist on all sides of the actual center of the canvas or stem from that center to the surrounding areas. The main motif can be placed in the center with minor elements to left and right and above and below; or relatively equal motifs may balance from side to side or top to bottom or both.

Unless the intention is decorative, symmetrical balance must be destroyed as well as maintained. This is done by embodying severe enough contrasts to make the balance of tensions unequal while maintaining relative over-all symmetry.

Non-symmetrical balance is that which utilizes the principle of leverage. Here the center becomes a fulcrum with a large area of tension on one side balanced dynamically on the other by a small weight or tension at an appropriate distance from the center. The artist's sensibility is the scale that determines this position and relative size.

Usually paintings are overly balanced; when this happens, static tensions

PLATE 103

OVERLOOKING LOWER MANHATTAN

In both works dominant shape is rectangular, secondary shape triangular, and opposition circular. Both have irregular dark pattern moving outward in spokelike manner.

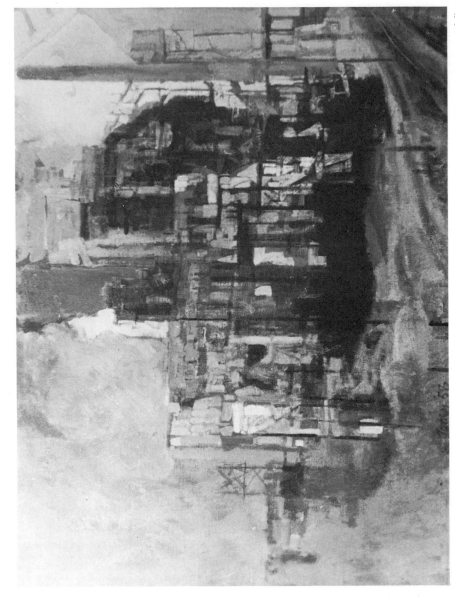

CONNECTICUT BUILDING

Main texture theme is counterpoint of flat simple areas and more complex ones.

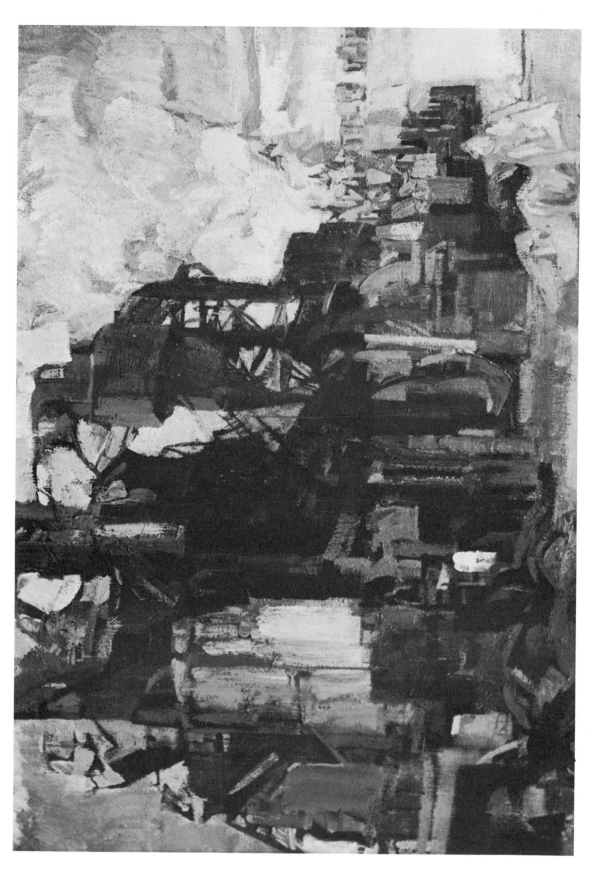

PLATE 104. INDUSTRIAL BUILDING ON STATEN ISLAND
Space idea is dominantly low-relief-like progression of movement back and forth within
shallow space. Near space has minor opposition in suggestion of distance at lower right.

PLATE 105

Main linear and shape theme is conflict of vertical and circular movements and
rectangular and circular shapes, the latter being dominant.

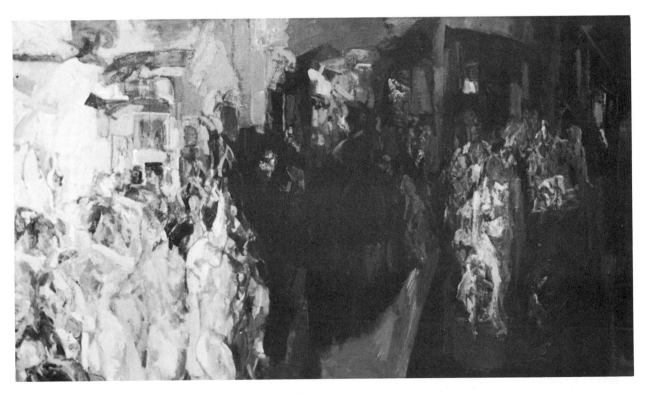

THE SUBWAY
Relatively simple dark and light pattern holds labyrinth of movement and
countermovement of plastic and psychological ideas.

PLATE 106

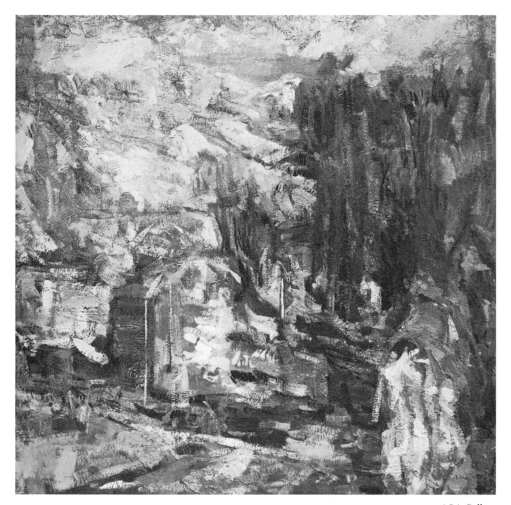

WINTER AT GREAT NECK

ACA Gallery

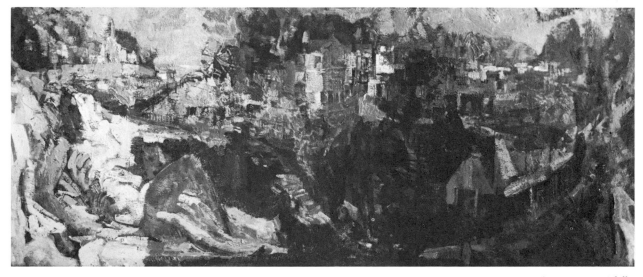

Collection of Mr. and Mrs. George Schiller

AT REST OVERLOOKING MOUNT KISCO
The main space idea in both works is a counterpoint of far and near positions.

are created that cancel one another so that the eye cannot move, direction is lost, and muddiness and confusion result. The creative artist will seek to obtain a more precarious balance, one that seems about to topple but does not.

As with color schemes, each thematic sequence is one of two types. Whether it is main, minor, or opposition, each theme is based either upon *domination* or upon *contrast*.

A *domination* idea is one in which there is but one main contradiction; this permeates all others, which serve to resolve it. Thus most of the shapes in a painting may be triangular, most of the directions diagonal, most of the values dark, most of the texture rough, most of the color red, and so on.

A theme based upon *contrast*, on the other hand, contains two main oppositions relatively equally stated and at least two contradictory systems, each of which is resolved through its influence upon the other. Thus the triangular shape may be pitted against the circular, but progresses as the triangular and the circular modify one another, together with other internal influences. One of the contradictions must be stronger; if they are exactly equal the movement becomes paralyzed.

Our main means for dissecting organizational relationships is that of noting the opposition extremes within each element. Primary aspects are those that combine in some form to make a more complex shape, direction, color, and so on. Just as any complicated shape can be seen in terms of the main geometric shape into which it fits and of the primary shapes that compose it, so can the shape ideas in a canvas be ascertained in terms of triangle, circle, and rectangle. By dissecting the complex into simpler components and by contrasting the complex with the simple, the analysis of the work as well as of its resources is carried out. In this way control is gained over components for whatever purpose the artist desires. Seeing both similarities and differences of any element is the basis of *visual generalization*, or order in art.

Organization is not a static process, performed once and for all. In the actual work on a canvas, as one idea becomes pitted against another, the relative strength of contradictions is often altered and minor ones become major. Our first ideas may require considerable alteration before a satisfactory resolution is found.

The guiding thread of this dynamism of change is the artist's internal awareness structure stemming from and influencing his relationship to his environment. Just as a person can accept certain patterns and not others, the artist will make the work in his own image. The discoveries embodied in the canvas, however, will change the artist and his image, and this change will determine the works that follow. The development of the work and the artist are intertwined, and both follow the same process.

A work of art expresses both ordinary and inspired human spirit and action. It is or can be whole but not an ideal whole. One level of complexity will lead to another, one problem to another.

In this situation the classicist will seek the ideal and may feel he has an ideal frame of reference that is absolute. The romantic, full of his own

PLATE 107

Sequences of planes that line up either accidentally or deliberately become bases
of thematic rhythms, relatively regular repetitions (with variation) of movement
and thus shape as well.

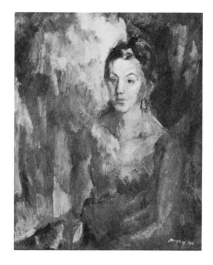

ANITA

PLATE 108

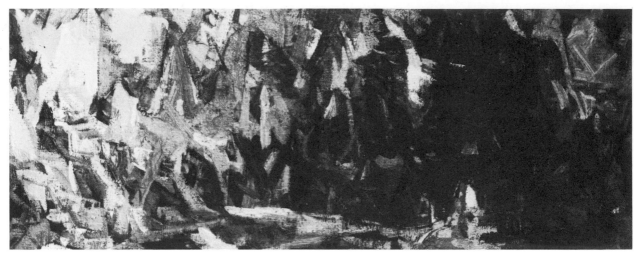

ACA Gallery

BRIDGE EXIT
Organization is necessary but is not the whole thing.

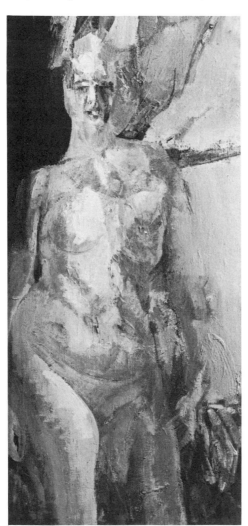

The essence of art is freshness and significance of experience embodied in wholeness.

WOMAN

PLATE 109

Exercises that stress similarities and continuities of direction can help you learn to see plastically. Gesture drawings can help to provide the extraction of line as movement or direction rather than simply description.

Contour drawings, on the other hand, help make you sensitive to shape, but shape which is tied to descriptive as well as psychological considerations.

present existence, will be distrustful of absolutes and seek none. For the naturalist, involved in the structure and appearance of nature, the organization of the canvas will take care of itself. For the realist, organization will be the resolution of a problem; it will be sufficient that the work possesses some truth even if not the whole truth.

Most students find organization difficult, particularly the form that goes beyond mere arrangement. Exercises that force one's attention to relationships of particular elements are worthwhile. Try extracting similar shapes or directions in some problems; stress particular continuities of direction in others. Experiment with many kinds of pattern. Learn through practice what is meant by a plastic generalization, by cross-fertilization of ideas. Learn to recognize flashes of insight. You will learn to give meaning to verbalisms as you rediscover their significance. Such development requires time. Patience is an absolute necessity.

In your work ensure contrast and prevent equality of tensions. Avoid too many ideas in one work. Some idea must be really strongest without at the same time appearing obvious.

If you wish to work from the figure, derive your plastic ideas from it. The figure is your resource. Avoid mechanically imposing plastic ideas on it.

Organization is a necessity in art but it is not the whole thing. The essence of art is the freshness and significance of experience embodied in wholeness. Be yourself. That is your path to freshness. Test other ideas with your own sensibility. Be open but also unafraid to reject what makes no sense to you.

Seeing Whole

A major difficulty for the student lies in his tendency to subordinate the whole to the part, to the present interest. His anxiety about a single detail prevents the perspective which would help him place it where it belongs.

Artists have employed various means for handling this problem, most of them involving some form of distance. Simply to have room to walk away from one's canvas is a help. Lacking this, one may periodically set the work away from oneself or change its environment; it can be taken into another room.

Time is the artist's most effective aid in this regard. Time permits many trials to occur and current subjectivity to be overcome. Eventually the parts reveal their qualities and take their proper places. The creative process requires time, time to follow its own logic as influenced by particular circumstances. Time allows the artist to see his work in relation to other works in his own and other people's studios, in galleries and museums, in the context of all art.

The use of time means that one must work on many things simultaneously. These should be hung where the artist can see them while he does other things; time will finish his work.

Seeing one's work through the eyes of others is another form of distance.

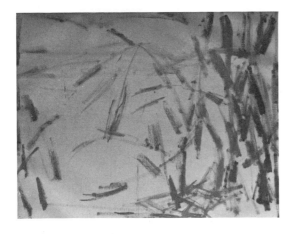

A. *Working against white of canvas, vertical and diagonal thrusts are contradicted by suggested circular movements.*

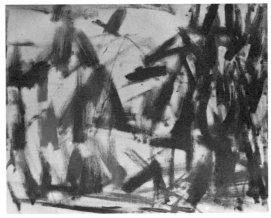

B. *Circular movements are stronger but do not overcome triangular main idea.*

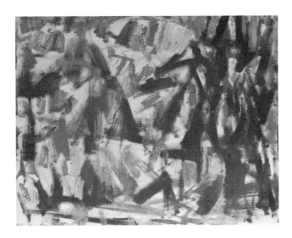

C. *More planes and value relationships reinforce suggested geometric counterpoint.*

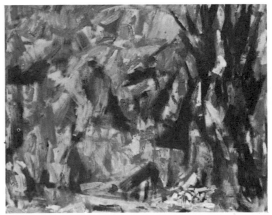

D. *Movements revolve about off-center axis with weight of darks thrown to right in explosive irregular spokelike pattern.*

This painting stems from ideas suggested in developing the painting "Renewal" (see Plates 6-7). Landscape-figure ambiguity remains point of departure for more explicitly geometric structure.

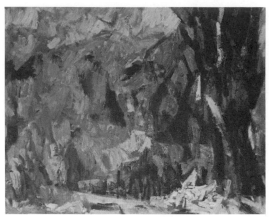

E. Addition of further middle tones softens contrasts; wheel-like idea thrown off balance by stress on vertical thrusts on right; darker tones elaborate earlier suggested rhythms.

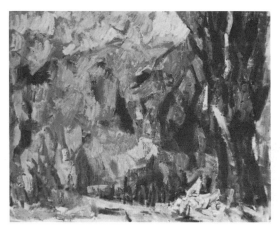

F. As more middle tones are added, rectangular shape idea becomes stronger, containing triangular and circular contradiction.

G

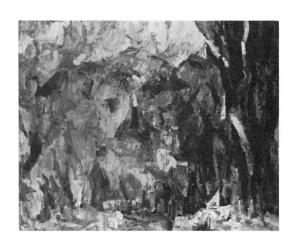

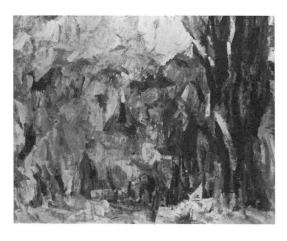

H. Light regained at left while further defining minor ideas; rectangular idea remains but is less explicit.

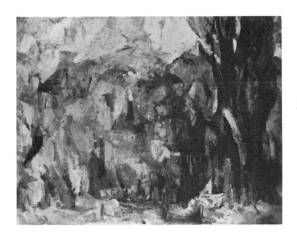

I. *Dark pattern strengthened and extended into left panorama; diamond-shape ideas clearer, sometimes explicit and sometimes implicit within circular movements.*

J. *Darks modified by middle tones carrying out further improvisation in minor repetitions of larger rhythms; editing begun.*

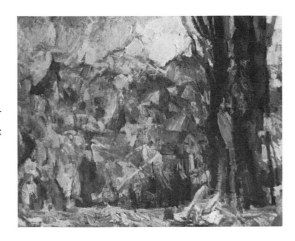

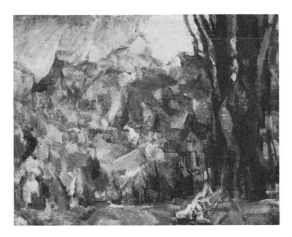

K. *Light pattern made more clear; more definite division in work sharpening rectangular shape idea.*
Further elaboration and editing toward greater clarity of progression of various plastic elements.
Light on figure at lower right foreground reinforces vertical idea.

Collection of Francis Schwartz

L. *Climax is at left of right strong vertical thrust.*

Triangular repetitions form subordinate theme reinforcing main shape theme while circular ideas become more implicit as countertheme.

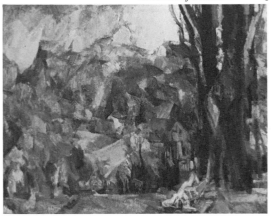

Whole is contained in simple contrast of large light left area with right vertical rectangular dark area.

Most artists have friends, some of them close creatively, who visit and react to current works. Showing such work is one form of what I call the social test, the conclusion of the creative process for a particular work.

Social Test

A work of art possesses intrinsic relationships which are as real as those of any other material experience. Both physical and psychological, objective and subjective, levels of organization participate in this reality. But this actuality, like all others, suffers various interpretations since it is seen subjectively even by the artist. Before the creative process can be said to be finished, the work should be subjected to a final test, the social test of being shown to others. Since that test is continuous, the creative process ends only with the work's destruction.

No one person may ever see the full aspects of a work. But it is most effectively understood in its own time by at least a few, even though general appreciation may come later. The artist knows it best though others may seem to recognize more of it. His knowledge, after all, is that of existence, of being: the work stands for him. It is at once his name and his idea, even as it is separate from him.

The artist's awareness of himself may be weak descriptively; he may lack psychological theory and practice, the necessary education to describe and interpret the manifold social relationships which are symbolized in the painting. Yet, being closest to it, he intrinsically understands most. That is why he must base his work on his own awareness. Others can influence that awareness but in no way substitute for it.

Those who have shared the artist's kind of experience will be most sympathetic to the work (and perhaps most critical of it) because they will also feel a great deal of its import or weakness. Others will respond in varying degrees, depending upon their own experience.

Description, or verbalized generalizations about the work, will extend the consciousness of the work for many and may help the artist to become more aware of himself. But no amount of description can possess the power and richness of actuality—whether that of the work, the artist, or his time.

Yet the actuality of the work is its strength. It exists separately and its relationships in their "relative absoluteness" remain to function as they can with any human who chooses to look. Long after the artist's own generation has vanished, works continue to embody and communicate their discoveries. While the whole may never be as fully felt as it was in its own time, it may reveal even more of certain of its discoveries to other times more prepared to understand them.

Each generation will see in terms of its own needs, its own levels of awareness. The capacity of a work to weather transient subjectivity determines its measure of profound discovery. Its continued existence, however, does not derive simply from its originality or depth. Too many great works have

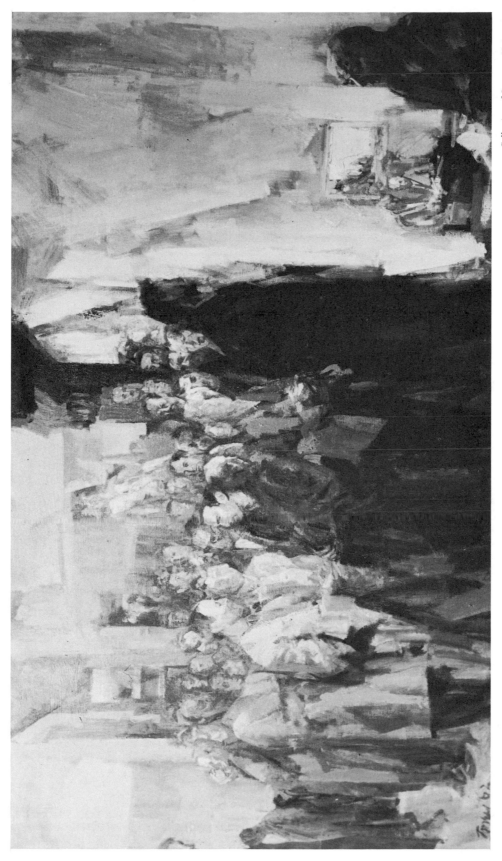

PLATE 113. GALLERY
For the professional artist the social test gets its impetus in a gallery.

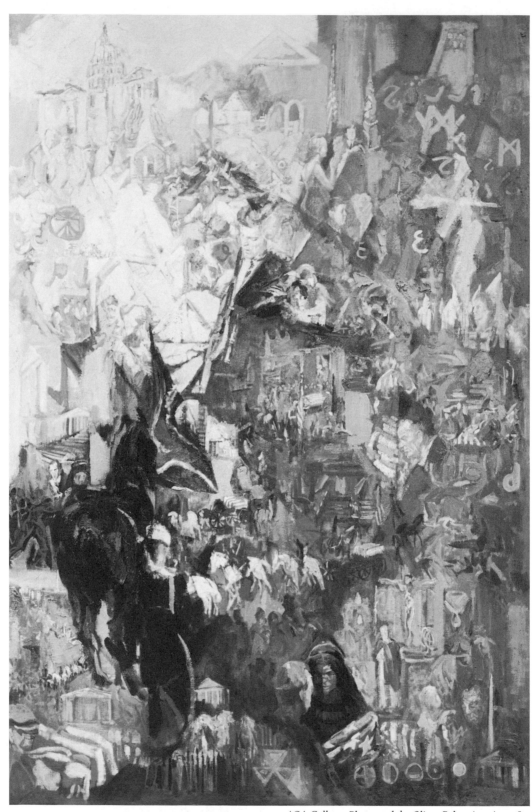

PLATE 114. THE ASSASSINATION

gone up in the flames of intolerance and bigotry for us to say that. Unhappily, only a relatively small portion of our artistic heritage still exists, and nuclear stockpiles hardly presage security today. In this struggle for survival, consensus may seem relative, accidental, and wasteful, but it is our only present means for evaluating and preserving works of art.

Beauty

It might be asked how it is possible to write even so short a book on art and not mention beauty. Is beauty not a present concern of painting and drawing?

The word "beauty" is as difficult as words like "talent" or "happiness," in that it can and does mean almost anything. If, however, it is used as a symbol to which particular content is given, it might be given pertinence.

Traditional concepts of beauty move along lines that are familiar to the reader by now. The classicist envisages beauty as the essence of reality or self-fulfillment of form. The romantic sees it as a manifestation of will or feeling determined subjectively by each beholder. The naturalist finds it in skilled correspondence to nature. The realist considers that beauty exists both in the object and in consciousness. Attempts to define what beauty actually is revolve about the fulfillment of purposes derived from one's particular view of reality. And in that sense the word becomes unnecessary.

Unnecessary or not, however, the word "beauty" is still used, even by artists. A specific kind of feeling, moreover, is associated with it, as one discovers if he attempts to examine the feeling experienced in front of a work of art. First of all, it is associated with great sensuousness. "Beauty" as experienced by viewers is a pleasurable sensation, a visual one yet one which affects the whole body and the whole person. Further, the source of this pleasure stems from the totality of the visual relationships, particularly as they work to give the viewer what can only be described as the sense of life—not life as appearance but of function toward fulfillment or resolution, of the relations in the work.

This beauty is not beauty of form separated from content, but precisely that of the synthesis of the various levels of meaning and impact. Stress on the pleasurable aspect of beauty has too often made it seem an embellishment or decoration of life. It has been turned into a pleasant or entertaining thing to have around, a spot of color to brighten a room, a possession that titillates the sensibility, something to show off.

But art is far more profound than any of these. It at once penetrates existence and embodies that penetration with a new existent, a new functioning reality. It radiates the beauty of its life, but the stuff of that life is our own.

INDEX

progress in art, 6
progressions, 173
psychological associations, 91, 95
psychological color, 164, 166
psychological distortion, 12, 99
psychological identification, 48, 59
psychological projection, 153
psychological tension, 161
pyramid, 136

qualitative change, 172
qualitative transformation, 172
quality, 162–163
quantity, 162–163
quick-drying white, 80

rabbitskin glue, 40
Raphael, 6
reaction in art, 6
realism, 105, 195
realist, 14, 153
reality, 18, 88
red sable, 43
regionalist, 158
relationships, anatomical, 110
 force, 67–69, 136, 150–153
 plastic, 77
Rembrandt, 65
Renaissance, 80
resolution, 172
rhythm, 18, 173, 179, 189–191
rhythmic, 98
Rivera, 39
romantic, 12, 128, 184, 188
romanticism, 38, 105, 153, 195
Rubens, 13, 65, 123

sabeline, 41
Sargent, 75
saturation, 160
scumbling, 75, 80
secondary, 161
secondary color, 36, 157
seeing whole, 188
sensation, 195
sensibility, 8, 10, 13, 18, 24, 111, 118–123, 153,
 179, 188

shade, 162
shadows, 138
shapes, 18, 48, 52, 56, 131, 133, 188
 explicit, 59, 133, 136
 geometric, 61
 implicit, 59, 136
 primary, 134, 138
shape pattern, 74
sienna, 36, 80
silhouette, 51
Siqueiros, 39
skills, development of, 172
Sloan, John, 75
social realist, 158
social test, 18–19, 24–25, 192–193
space, 18, 95, 118, 136–137, 152, 181–183
 actual, 150
 illusionistic, 136
 naturalistic, 145
space orchestration, 150
sphere, 136
stand oil, 38
static, 179, 184
stream of consciousness, 94–95, 106
stretchers, 40
structure, 10, 13–14, 21, 24, 74, 76–77, 113–115
student, 29, 31
studio, 43
subordinate themes, 162
symbol, 19, 24, 58
symbolic color, 166
symbolic image, 14, 53, 102, 174
symbolism, 18, 20, 95, 105, 107, 153
surrealists, 99
symmetrical balance, 177, 179
synthesis, 8, 10, 13, 15, 194

talent, 29
technique, 35
technology, 153
tertiary complement, 160
test, 172
texture, 18, 95, 117, 166, 180
 actual, 166–169
 illusion of, 169
 visual, 169
thematic progression, 173
thematic sequence, 18, 68–70, 76–77
thematic structure, 173
thematic variation, 174
themes, 171